GETTING
CLOSER

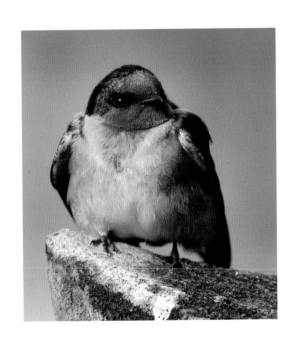

About the Author

Paul Sorrell took up photography in the early 2000s, giving him a new form of creative engagement with his longstanding interest in wildlife and the natural world. His images have featured in local, national and international wildlife photography competitions, and he has published online and print pieces for outlets ranging from airline magazines to Tourism New Zealand's website and the *School Journal*. He has worked in the area of books and publishing since the 1980s, copy-editing, writing for academic and popular journals, and publishing four books about his home province of Otago with Penguin Random House.

GETTING CLOSER

Rediscovering nature through bird photography

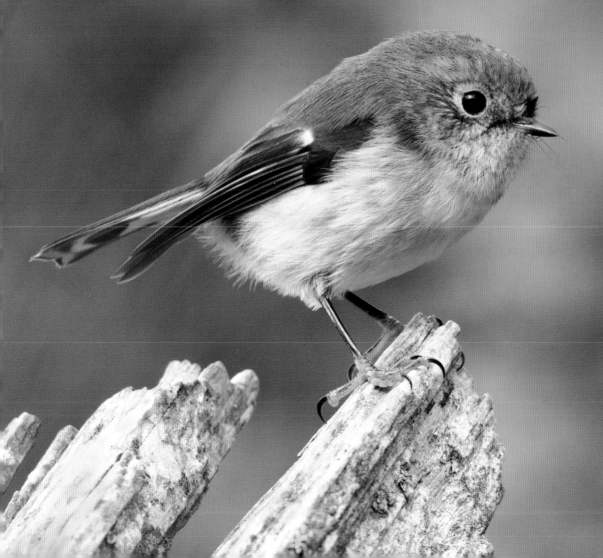

PAUL SORRELL

For Neale and Ursula

First published 2021

Exisle Publishing Pty Ltd
PO Box 864, Chatswood, NSW 2057, Australia
226 High Street, Dunedin, 9016, New Zealand
www.exislepublishing.com

A CiP record for this book is available from the National Library
of Australia.

ISBN 978-1-925820-63-8

Designed by Mark Thacker
Typeset in Myriad Pro Light 10 on 15pt
Printed in China

This book uses paper sourced under ISO 14001 guidelines
from well-managed forests and other controlled sources.

10 9 8 7 6 5 4 3 2 1

Additional photographs courtesy of Shutterstock, as follows:
front endpaper Protasovan; p. 12 Yanikat; p. 48 Pongwan; p. 49
Riverheron; p. 56 Yuan7412; p. 65 Wim Hoek; p. 85 picoStudio;
p. 88 Steve Collender; p. 94 Nickolay Kovachev; p. 103 Ondrej
Prosicky; p. 118 Shulgenko; p. 121 guteksk7; rear endpaper
Balazs Kovacs Images.

contents

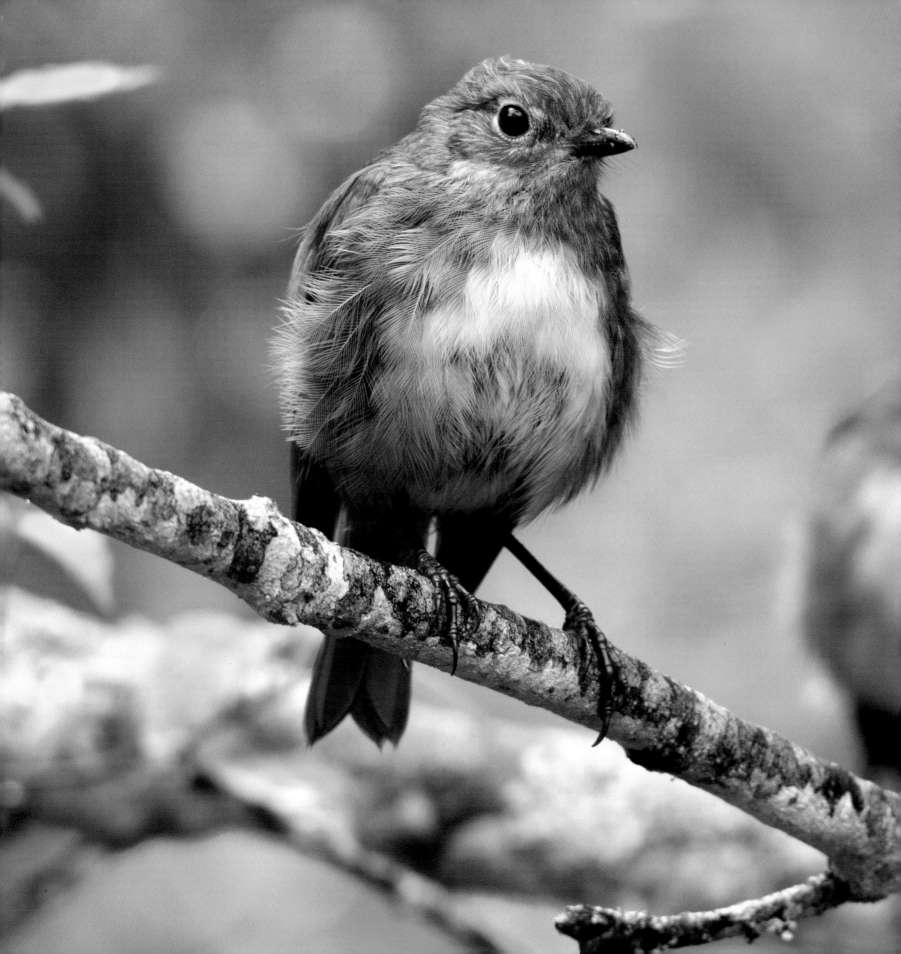

Preface

Over the decade and a half that I have been active as a wildlife photographer, I have practised some standard techniques that have allowed me to get close to birds, as well as developing some of my own. I have found that with physical proximity there has come a sympathetic attachment based on a growing understanding of my subjects and how they live out their lives, whether in my back garden or the forests, lakes and mountains of southern New Zealand.

My aim in this book is to pass on the knowledge and fieldcraft techniques that I've accumulated as a photographer and nature lover (I'm not sure which comes first) to help readers achieve a connection with wild places that is sorely needed in this time of ecological crisis and widespread despair about the future of our planet. I've found that intimacy with nature can bring not only understanding, but also joy.

So this book is aimed at multiple audiences — birders, people interested in the outdoors and those who simply want to strengthen their connection with the natural world, as well as photographers (of all levels of ability and experience) looking to improve their wildlife skills. I've tried at every turn not just to present information and give practical tips, but to reflect on what it means to encounter, appreciate and record the natural world, especially of course the birds. I make no apology for this approach — for those wanting more technical information there are excellent guides available such as Ross Hoddinott and Ben Hall's *The Wildlife Photography Workshop* (Ammonite Press, 2013) and Richard Bernabe's *Wildlife Photography: From first principles to professional results* (Ilex, 2018).

Whatever use you make of this book, I hope that it will not only spark your creativity and enrich your appreciation of nature, but also enhance your understanding of our living planet, our wonderful, irreplaceable home.

Paul Sorrell
Dunedin
February 2021
paulsorrell.co.nz

Introduction

Few would disagree that we are facing an ecological crisis of global dimensions, the like of which the human race has not experienced before — our very survival on this planet is at stake. At first blush, this might seem like a book about an appealing, if slightly indulgent, hobby. But in reality its subject could hardly be more important.

Global warming, the degradation of the world's remaining wilderness areas, the tsunami of plastic being dumped into the oceans — there's little point in merely repeating this litany of environmental disaster that serves only to depress us.

If the human species is ultimately under threat, animals are disappearing at a disturbing rate. According to the World Wildlife Fund's *Living Planet Report* for 2018, wildlife populations across the globe have fallen by 60 per cent over the past 40 years. And now (May 2019), in the most exhaustive report of its kind ever compiled, the Intergovernmental Science-Policy Platform on Biodiversity and Ecosystem Services (IPBES) has found that 1 million animal species are at risk of extinction, and numbers of large mammals have declined by 80 per cent since the 1970s, largely through the destruction of their habitats.

According to the IPBES study, a quarter of all animal and plant species are under threat, as we continue to ransack the natural world to provide food and energy for the planet's burgeoning human population, especially in urban areas, which have doubled in size since 1992.

Birds are not immune from these destructive trends. In a recent study published in the journal *Science*, the authors conclude that there were 3 *billion* fewer birds in the United States and Canada in 2019 compared to 1970 — a drop of 29 per cent. These losses have occurred across all types of habitat, from grasslands to coasts to deserts. They include not only rare birds, but common species that people encounter every day in their backyards. According to lead researcher Dr Ken Rosenberg of the Cornell Lab of Ornithology and the American Bird Conservancy, the major factor in this sharp decline is 'habitat loss driven by human activity'.

Even in my own small corner of the globe, the dangers faced by birdlife are all too evident. Here, the yellow-eyed penguin — probably the world's rarest penguin — is fighting to survive. The 'yellow eyes' that I so confidently photographed a decade ago as they returned from the sea after a day's fishing are an increasingly rare spectacle. These feisty seabirds are facing a barrage of threats, from avian disease to starvation as a consequence of reduced fish stocks and damaging fishing practices such as set netting and bottom-trawling, all exacerbated by ocean warming. So rapidly are their numbers declining that one authority has predicted that they could disappear from the New Zealand mainland in ten years. Addicted to our screens, large and small, people in the West, and increasingly those in the booming economies of Asia, are disconnected from nature. 'We are not separate from the wild world', says self-described forest gardener Robert Guyton. 'It is going to realign us fairly soon … unless we recognise that we need to be fully integrated into that world.' As a species, reconnection with nature is our most urgent task.

It all seems too big to think about, let alone tackle.

While governments and industry twiddle their thumbs, people all over the world feel disempowered, knowing that individuals can only do so much to right the balance. A new disorder is taking hold — climate change anxiety. Even people not directly affected by drought and sea-level rise are being mentally impacted. In the words of a report led by psychology professor Susan Clayton at the College of Wooster, 'the ability to process information and make decisions without being disabled by extreme emotional

(Previous page) Two South Island
robins in their lowland forest home.

Camera: Canon EOS 7D. *Lens:* EF400mm
f/5.6L USM. *Settings:* 400mm ƒ/6.3 1/320 sec
ISO 800. © Paul Sorrell

The yellow-eyed penguin — very likely
the world's rarest penguin — is under
serious threat.

Camera: Canon EOS 20D. *Lens:* EF400mm f/5.6L
USM. *Settings:* 400mm ƒ/5.6 1/2500 sec ISO 200.
© Paul Sorrell

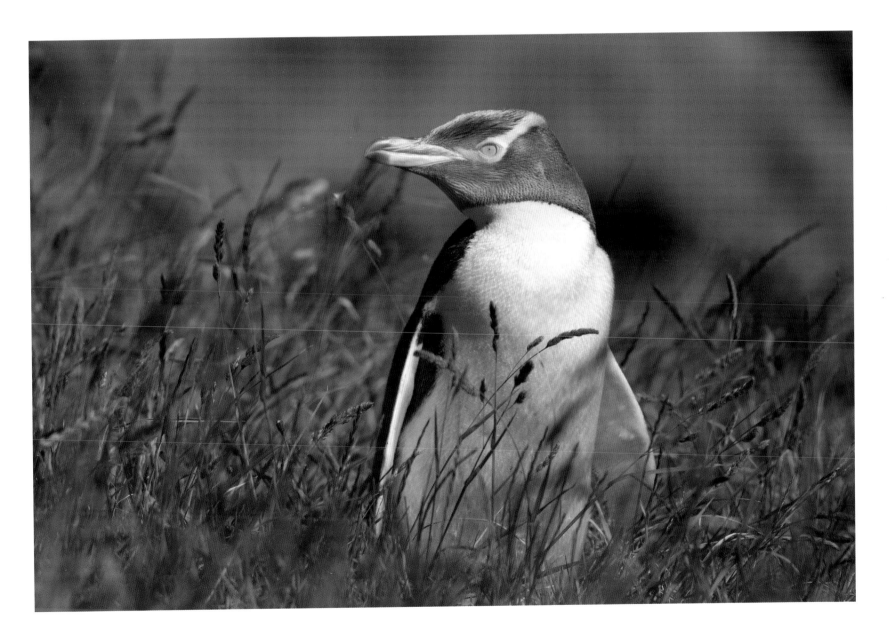

responses is threatened by climate change'. Some couples are deciding that bringing children into an unliveable world is morally wrong. For Caroline Hickman, a researcher at the University of Bath, part of the solution to such disabling anxieties is to acknowledge the validity of one's emotional response and take positive steps such as joining an activist organization or a climate discussion group.

Taking some kind of action, however small, is the first step to a healthier relationship with the planet. We need to discover modest, inexpensive, doable ways of reconnecting with nature that are accessible to everyone and, above all, enjoyable.

This book offers such a prescription. In the following pages you'll find practical suggestions for enhancing your connection with the natural world by sharpening your awareness of what lies around you.

So what's stopping us? Why have we grown so estranged from the natural world? For people in the West, part of the answer is our urban lifestyle, a process that has advanced over the last few hundred years in fits and starts. We buy our meat from supermarket refrigerators and our milk in plastic bottles. With little need to interact directly with nature, we have made our homes in the suburbs amid asphalt and concrete; some of

us are lucky to tend manicured versions of wild nature that we call gardens. Parks and reserves in towns and cities extend the illusion, allowing us to appreciate the beauty of the outdoors, but without experiencing the risks associated with the wild. More often than not, the 'fight or flight' mechanism that our species evolved to meet such threats has nowhere to go, contributing to the contemporary epidemic of stress, anxiety and depression.

Nature deprivation starts young. There is growing concern over the many millions of children in a rapidly urbanizing world who are growing up tied to electronic screens, or cramming for exams that will fit them for a lifetime of working absurdly long hours wrapped in urban cocoons.

In a Canadian study of 4500 children across the United States led by Dr Jeremy Walsh, a researcher at the Children's Hospital of Eastern Ontario Research Institute, Ottawa, only one in 20 of the children studied met standard guidelines for good cognitive development: nine to eleven hours of sleep, less than two hours of recreational screen time, and at least an hour of physical activity every day. The Longitudinal Study of Australian Children, which has been tracking 10,000 children since 2004, found that their subjects' screen time increased with age, amounting to a staggering

30 per cent of a child's waking time by twelve to thirteen years old. Significantly, the study also found that children who engage in physical activities that they enjoy spend less time on their electronic devices.

The situation is similar in the United Kingdom. In 2012, the British National Trust reported that fewer than one in ten children regularly played in wild spaces, compared to half the children of the previous generation. And a 2016 study found that three-quarters of children in the United Kingdom spend less time outdoors that prison inmates — less than an hour a day. In his book *Last Child in the Woods*, American author Richard Louv has given this phenomenon a name — 'nature-deficit disorder' — and linked childhood nature deprivation to problems such as attention disorders, obesity and depression, as well as the loss of mental agility and creativity.

However, the good news is that we are waking up to our radical disconnection from nature and seeking ways to reverse it. The IPBES report suggests that we can stave off disaster by promoting 'transformative change' that will mean rejecting the current paradigm of unlimited economic growth and consumption, as well as stopping subsidies for fossil fuels and industrial-scale farming and fishing. And much more of

the planet needs to be protected as wild spaces — they suggest a goal of 50 per cent by 2050, with an interim goal of 30 per cent by 2030. The authors of the *Science* bird study make the point that if duck hunters can successfully restore wetland habitats for their sport, conservationists can surely do the same. All it takes is the will.

Momentum for change is building. The media ensures that we cannot ignore the protests of the Extinction Rebellion movement or the global school strikes led by Swedish teenager Greta Thunberg in response to the failure of her parents' generation to ameliorate climate change.

A host of other initiatives are less likely to make the headlines. In the United Kingdom, the Wildlife Trusts and the Royal Society for the Protection of Birds (RSPB) are jointly pushing for a Nature and Wellbeing Act that would link ecological restoration to the mental and physical health of individuals and deliver major social, health and economic benefits for the wider community. And in Wales, part of an estate in the Brecon Beacons has been handed over to a group of 20 teenagers who are working with tenant farmers, landowners and local conservationists to restore impoverished habitat and explore new, biodiverse approaches to farming and forestry.

Most conservation organizations have youth wings that encourage children to learn about nature and the threats to it. Canada's leading youth conservation organization, Earth Rangers, seeks to change the outlook and attitudes of its 200,000 young followers: 'Rangers Members are not only more engaged in environmental behaviours, but are more optimistic for the future, more confident in their ability to affect change, and are more altruistic, showing a greater concern not just for the environment but for other social issues.'

In the United Kingdom, RSPB Wildlife Explorers describes itself as 'the largest children's environmental club in the world', and over-twelves can become members of RSPB Phoenix. In the United States, the National Wildlife Federation has been working for decades to connect children and youth with nature; one of its initiatives is the Green Hour program, designed to encourage parents and caregivers to commit to a goal of an hour a day for children to enjoy the outdoors, hopefully implanting a lifelong love of nature. In New Zealand, the Department of Conservation encourages youngsters to become Kiwi Guardians. Members of Forest & Bird can enrol their children in the Kiwi Conservation Club, after which they can graduate to Forest & Bird Youth (for ages fourteen to 25).

Children are being encouraged to be citizen scientists. Through websites like iNaturalist and zooniverse.org they can identify plants and animals they have found in their own backyards and make a real contribution to knowledge. Taking part in a garden bird survey, creating a 'compostarium' in the back garden or joining in a local 'bioblitz' (identifying as many species as possible in a given area over a short time) can all be great fun. All over the world, concerned parents are taking their kids out to roll in the autumn leaves and splash about in woodland streams. The British film *Project Wild Thing* chronicles filmmaker David Bond's efforts to re-introduce children to the wild, laced with strong doses of optimism and humour.

Adults are also realizing that they can have fun while cleaning up the planet. Plogging, a trend which began in Sweden around 2016 and involves picking up rubbish, especially plastic waste, while jogging, has spread as far as India, Thailand, Ecuador and New Zealand. In New York, Plogging NYC, a group formed on meetup.com, is slowly working its cleansing way around the city, paying special attention to parks and running paths. Another group is active in Indianapolis, where Summer of Plogging was organized in 2018. And in New South Wales, Australia, the

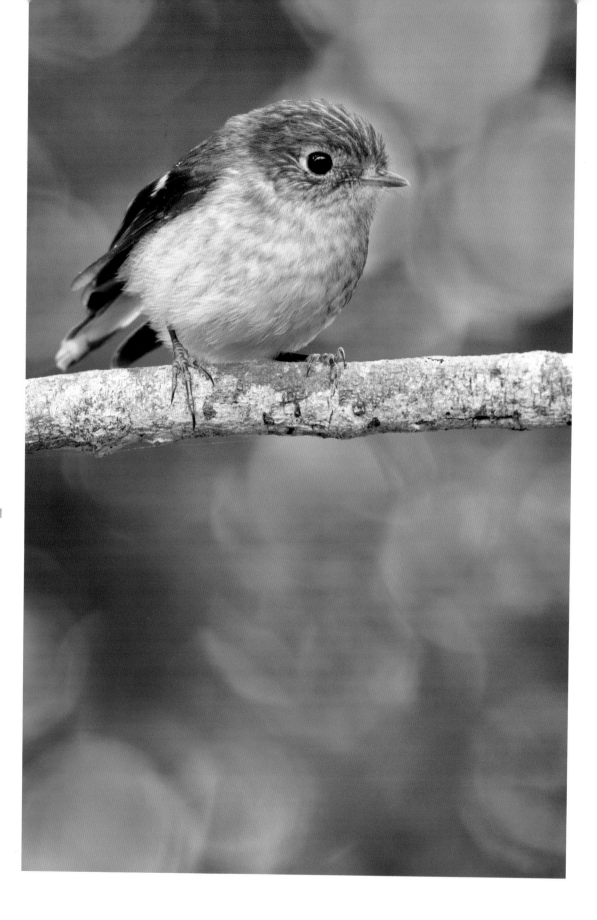

A walk in a nature reserve, where this tomtit was photographed, can have a restorative effect on city dwellers.

Camera: Canon EOS 7D. *Lens:* EF400mm f/5.6L USM. *Settings:* 400mm ƒ/6.3 1/80 sec ISO 800. © Paul Sorrell

Byron Bay Runners have fully embraced this 'Scandi' trend as they pound local beaches, rubbish bags in hand. This innovative and healthy response to a major environmental problem caters for all ages and fitness levels.

In South Korea, where academic pressures and work stress are particularly high, strung-out citizens can relax in government-sponsored 'healing forests'. In Japan, stressed city dwellers can take advantage of *shinrin-yoku* or 'forest bathing', immersing themselves in unspoilt natural locations to relax mind and body. There are more than 60 official forest therapy trails in Japan; activities range from forest walks to listening to natural sounds such as streams and waterfalls, handling trees and wood, and using essentials oils derived from trees and plants. Forest therapy is increasingly being embraced beyond Asia, with promotional bodies in the United States, the United Kingdom and Australia.

People in the West are waking up to the fact that the simplest types of exposure to nature can be beneficial. A celebrated paper by Roger Ulrich published in *Science* in 1984 showed that hospital patients with windows giving views of trees recovered more quickly than those looking onto brick walls. Since then, scientists have shown that people living close to green spaces enjoy

significantly better mental and physical health than inner-city dwellers. And a short stroll in the woods or park improves things even further, lowering stress hormones, heart rate and blood pressure. As well as making us calmer, exposure to nature can increase personal empathy, improve our mood and help stave off negative emotions. Just seeing grass and trees outside your window, or even viewing pictures of natural scenes, can contribute to human wellbeing.

It's little wonder that we respond positively to exposure to nature when given half the chance. There is a good reason why we feel so relaxed in nature — we evolved there over 7 million years or so. In his book *The Moth Snowstorm*, Michael McCarthy reminds us that humans have been farmers for 500 generations, since the end of the last ice age 12,000 years ago. Before that, we spent 50,000 generations as hunter–gatherers, profoundly attentive to the rhythms of the natural world. McCarthy adds that we've spent three or four generations as office workers — and only one as screen junkies. Wandering through forest or parkland, in the wetlands or along the beach gives our overworked brains a much-needed rest: the way in which natural scenes gently unfold as we walk allows our minds to slow down and recover from the over-stimulation of city life. According to

cognitive neuroscientist (and hiker) David Strayer, three days spent in the wilderness allows our brains and senses to recalibrate.

While all this makes good sense on paper, we have become so habituated to a sedentary lifestyle that it seems easier to sink into our easy chair and settle down to binge-watch the latest Scandinavian crime thriller on Netflix than take a walk in the woods. In the United Kingdom, the Health Survey for England 2017 found that although most adults met standard guidelines for aerobic activity, 64 per cent of adults were overweight or obese, with children of overweight or obese parents more likely to be obese or overweight themselves.

According to a 2018 report from the Centers for Disease Control and Prevention's National Center for Health Statistics, less than a quarter of Americans are meeting all national physical activity guidelines. Healthy alternatives are not always easy to access. Most notably, America's national parks are rapidly becoming victims of their own success, with burgeoning visitor numbers (331 million in 2017) clogging park roads, overwhelming facilities and flocking to take selfies at scenic hot spots promoted on Instagram. US national parks seem to be becoming picturesque versions of the nation's

cities — Yosemite even has a branch of Starbucks.

Turning to the Antipodes, according to the Australian government's National Health Survey for 2017–18, the typical Australian does 42 minutes of exercise every day (mainly walking), is overweight or obese and does not eat enough vegetables or engage in adequate strength and toning activities. And while New Zealand still prides itself on being an outdoors nation, the statistics are less impressive. According to Associate Professor Sandy Mandic of the University of Otago's Active Living Laboratory, only half of Kiwis meet the national guidelines for healthy levels of physical activity. And of the 114,012 people who completed one of New Zealand's Great Walks (such as the Kepler Track or the Abel Tasman Coast Track) in 2018, only 38 per cent were New Zealand residents.

But 50,000 generations of hunter–gatherers are hard-wired in our DNA. We still preserve reflexes of our ancient forebears, such as our tendency to avoid crossing large open spaces (we prefer to walk around the edges) or children's attraction to concealment games like hide and seek. However, most of us have lost the spontaneous bond with nature we had as young children, although memories of our early outdoor activities may be

fresh and vivid. I remember building crude huts in a patch of forest near our city home with my younger brother Chris (who must have been only four or five at the time) and, around the same time, digging fat white huhu grubs (beetle larvae) out of rotten logs at the back of the school, and encouraging enormous tree wetas — resembling oversized, armoured crickets — to climb up my arm to the horror (real or feigned) of the girls in my class of new entrants.

In his provocatively titled book *What has Nature Ever Done for Us?* Tony Juniper painstakingly lays out the evidence for our physical dependence on the natural world. From the rainforests that act as massive carbon sinks to the peat bogs and tussock lands that filter water clean and soak it up to prevent flooding, nature provides a host of essential services to *Homo sapiens*, the most destructive species on the planet. The story of the loss of India's vulture population after cattle farmers began medicating their herds with the anti-inflammatory drug diclofenac illustrates the cascade of destructive effects that can flow from one thoughtless intervention in a finely balanced ecosystem. Juniper argues that when the cost of environmental degradation is calculated, a strong case can be made for preserving the planet on purely economic grounds.

I would take this train of thought much further. We need wild nature — not just for utilitarian purposes, or even to preserve us as a species — but to keep us human, to complete our humanity. If we lose nature, we lose ourselves. The natural world brings us not only deep peace but also, as McCarthy has shown, an abiding joy.

Heading outdoors

If you are serious about reconnecting with nature, the first thing to do is to take a trip outdoors. I mean an outing undertaken for its own sake — not hurrying somewhere on the way to a more 'urgent' appointment. It doesn't matter if your trip takes you to a national park, a forestry plantation, your local park, or no further than your back garden. Having arrived at your destination, choose a place to stop and draw in some big lungfuls of air, breathing out slowly and deeply. This will relax your body as well as sharpening your mind and senses through the extra uptake of oxygen.

Become aware of where you are. Are you standing in an open space, like moorland or parkland, perhaps with scattered trees? Or are you in a forest? Or at the beach? What can you smell? Perhaps the heady coconut scent of gorse blossoms, or ozone? Or the pervasive musky odour

of a clump of Easter orchids? Listen to the sounds around you. Is that a blackbird fluting (where is it?), the popping of broom seed pods in the summer heat, or a helicopter in the distance? What do you feel? The warmth of the sun on your face, or the first plangent drops of gathering rain? Is it a dead calm autumn day, or is there a breeze shivering the leaves of a nearby grove of aspen trees?

And then you need to open your eyes, attuning them to register the slightest movement (which gives a creature's presence away) or simply to savour the play of the light on golden tussock or the vivid oranges and yellows of a Japanese maple in the autumn.

A few years ago, I learned a simple trick to enlarge my peripheral vision, at least for a few hours. Holding your arms in front of you around shoulder height, and looking straight ahead, slowly move your outstretched arms apart until they form a straight line of 180 degrees out to your sides, always keeping both hands in view. Try it — it really does work!

The aim of all this attending is to attune all our senses to the environment in which we find ourselves. To experience the natural world consciously and deliberately — 'mindfully', in modern parlance. If we can learn to approach

the world in this way, we shall soon begin to reap the rewards. We can increase our chances by selecting a promising area as our personal 'patch', visiting it again and again in all weathers and through all the seasons of the year. You will be astonished at the way Nature will surrender her secrets to you.

By returning again and again to the same spot, you will really get to know the place and the birds and other creatures that live and visit there, as well as the habitats (especially the plant life) that they depend on. Activity will slowly unfold around you as you wait. Give it time. Unexpected things will happen to delight and inspire.

Once you've achieved a certain level of intimacy with your chosen habitat or patch, you can begin to formulate your strategy as a photographer. And strategy is the key to success. You can't expect to just stroll in and come away with a memory card full of great shots. For many people, especially the young, this will be counterintuitive. In the 21st century we have created a culture of instant success — it is commonplace to hear people express the desire to be a top writer, musician or artist without putting in the hard yards. The instant communication technology we have surrounded ourselves with does nothing to combat this attitude. But as in any endeavour that

is truly worthwhile, there is no instant success in the business of wildlife photography.

Choosing your spot is only the first step. To take photographs that are more than hurried record shots — to make beautiful images — you'll need to think carefully about factors such as the direction and quality of the light, potential settings or backgrounds and where your subject will be best placed for the result you are hoping for — either to stand out against a neutral backdrop or suggest interaction with its environment.

Your choices will change depending on the habitat you select. In woodland or scrub, find a

spot where the birds are plentiful, backgrounds suitable, and there is plenty of open space for you to move around and take advantage of the clear light overhead. Clearings and woodland edges are ideal. Avoid the depth of the forest — these areas are usually too dark for photographing moving subjects, being more suited to long exposures.

As you spend time observing what's happening around you, at some point an image is sure to form in your head of the shot you want to get — a particular behaviour or intriguing pose. (But don't be so set on this that you miss the unexpected gem; nature is always unpredictable.) Patience, persistence and your growing familiarity with your quarry and its surroundings will eventually pay off. By getting to know your subject (and its habitat) intimately, you'll be able to *anticipate* its behaviour and be ready for that great shot when it presents itself.

So the first prerequisite of good wildlife photography is getting to know your subject. With practice, you'll soon become an expert in animal behaviour. What are the birds on your patch up to? Are they feeding, resting, preening, breeding, nesting, migrating? You'll discover that the best light for outdoor photography comes at the beginning and end of the day (the so-called golden hour), in conditions of hazy

cloud cover or in the gentler light of winter. You'll become attuned to the changing seasons and the behaviour and movements of birds at different times of year, especially their breeding, migration and feeding patterns. You'll become intimately acquainted with the weather, winds and tides in your local area, knowing when to go out and when to stay home and deal with your backlog of images from previous outings.

One of the great rewards of becoming familiar with one location, visiting it again and again, is that you will build up a multilayered picture of a particular habitat and how everything connects to everything else. Only by spending hours together in one spot will the life of the place reveal itself to you. You will gradually be able to put seemingly random animal behaviour into a wider context, joining up the dots. You may even be lucky enough to follow the same subjects week after week, piecing together something of the story of their lives. Momentary events will become significant, and apparently random acts take their place as markers in a bird's routine. The story of the male tomtit I came to know as Bung-eye illustrates this process well (p. 27).

One thing you will discover is that every animal is different in its attitude to people. Some, like sea lions, and shorebirds like dotterels, are very approachable, even indifferent to people. Others, like white-faced herons and bar-tailed godwits, will fly off as soon as they spot you. During my many visits to my local wildlife reserve, I have found that New Zealand robins are very curious and approachable; the same goes for juvenile birds — for example, tomtits, fernbirds and bellbirds — that have not yet learned to be wary of people and other potential threats. And in places like city parks, many birds have become habituated to people; I've found that my town's botanic garden is the best place I know to photograph blackbirds and dunnocks.

As you become more intimate with your subjects, you realize that animals live in a parallel universe to our own — they seek out mates, build homes, bring up their young, gather food and so on. As wildlife photographers, or just careful observers, we gain a privileged access to this world. If we enter their sphere with patience, understanding and respect, we will be rewarded with their acceptance. Even five minutes spent quietly around birds will encourage them to relax and carry on their activities as normal. Young Swedish photographer Johan Carlberg says, 'It's important to show gratitude and respect for your subject. If you feel connected to your subject, it will show.'

Sometimes, perhaps after a frustrating series of false starts, we find that we are suddenly 'in the zone', calmly observing our subjects as they go about their business, perhaps even venturing close to inspect their strange visitors. We can feel that we have been accepted into their world. Then we can begin clicking, taking shot after shot in a calm and considered way — very different from the 'grab shots' taken by the casual photographer. At such times, we enter a mental and physical space akin to meditation — our heart rate drops and time seems to slow down as we somehow enter into the inner lives of our subjects. When it happens it is wonderful, and the rewards can be rich.

Very occasionally, a wildlife encounter results in something akin to an epiphany. I shall never forget the time a kōtuku (white heron) dropped out of the sky and touched down a few feet in front of me as I lay beside a lagoon. With precise and elegant movements, this rare visitor calmly explored the shallows as if I wasn't there. The experience was enriched by my knowledge of this bird, which has a special place in Māori nature lore, and every winter disperses widely across New Zealand from a single breeding site on the West Coast of the South Island. For Māori, meeting one of these birds, perhaps once in a lifetime, is a great privilege; a rare and distinguished guest might

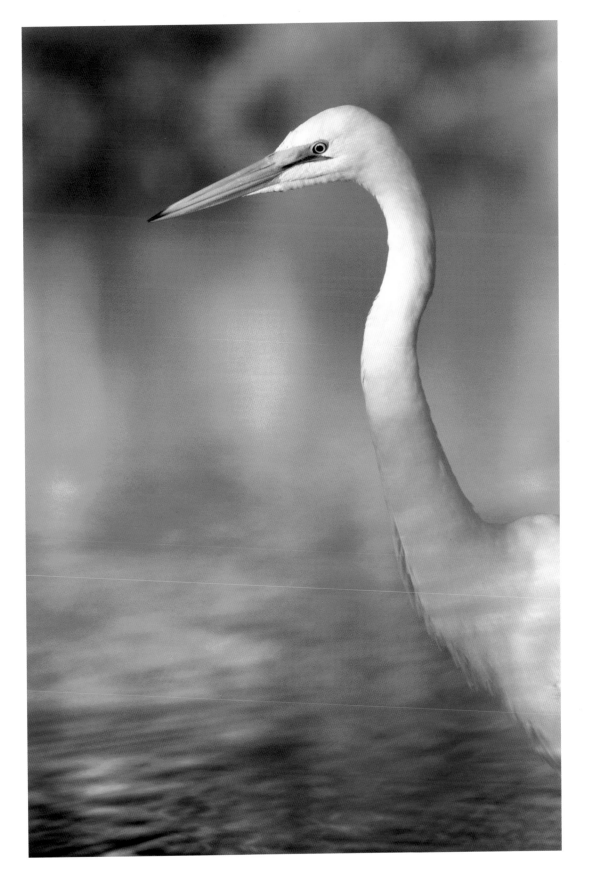

My encounter with this white heron beside a local lagoon engendered a sense of privilege and wonder.

Camera: Canon EOS 7D. *Lens*: EF400mm f/5.6L USM. *Settings*: 400mm ƒ/6.3 1/2000 sec ISO 400. © Paul Sorrell

be described as 'a kōtuku of a single flight'. I felt a quiet joy, a sense of being graced by this wholly unexpected visitation, a feeling of communion that must have lasted only a few minutes, but will stay with me always.

Over the last fifteen years I have accumulated a store of adventures, experiences, techniques and insights that are set out in the pages that follow. Whether you are an established nature photographer, a beginner, or simply wanting to find ways of drawing closer to nature for your own sake and the health of the planet, I hope that this book will be a useful and friendly companion on your journey.

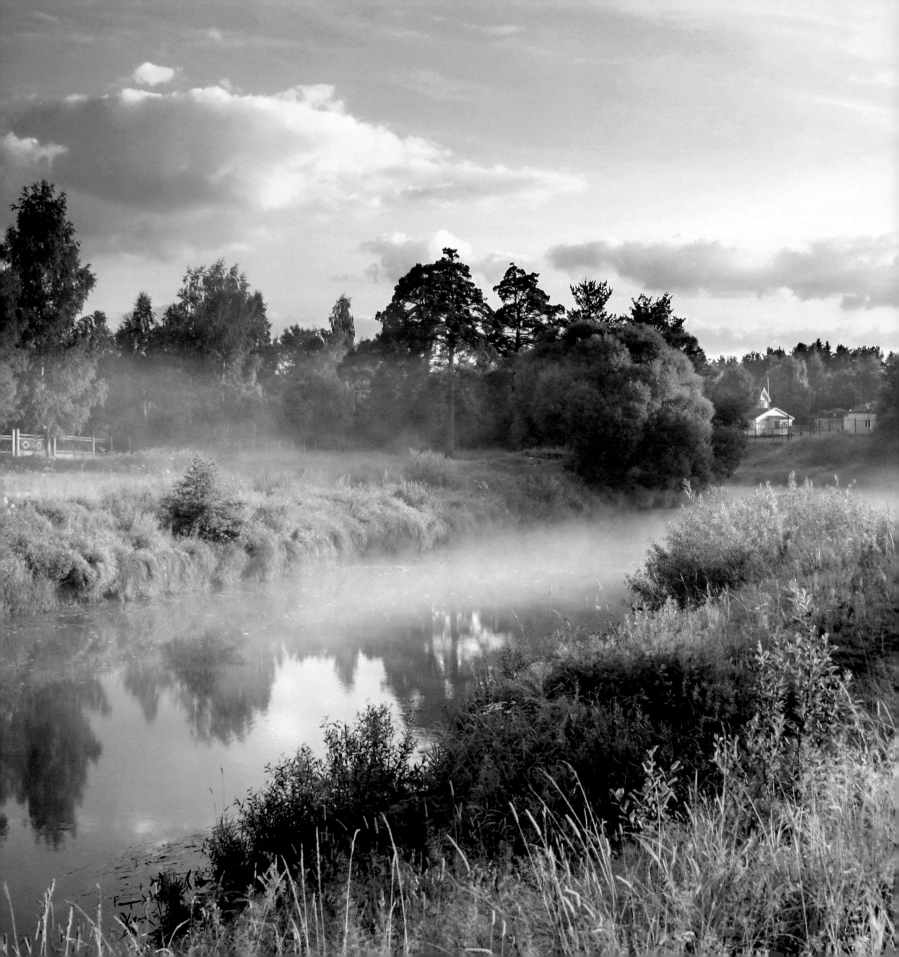

Encountering
the
outdoors

Natural rhythms
Tuning in to time and tide

For most of us, our lives are well-insulated from the changing patterns of the seasons. But, as a wildlife photographer, you will rapidly become re-acclimatized to nature's rhythms. Weather of all kinds will become your friend, whether it be sunshine, snow or hailstorms.

Each day brings its own unique weather system, enabling you to judge when the light is at its best (see pp. 58–61), what locations will be suitable for photography or whether you want to venture out at all. Provided that you protect your gear, adverse weather — rain, snow and darkening storm clouds — can endow your images with vibrancy and atmosphere.

If you prefer to stay at home, and you have a backyard set-up in place (see pp. 19–20), you can capture images from the comfort of your room or garden shed. A natural perch will of course change its appearance as the year progresses — the leafy boughs of summer giving way to the rich colours of autumn, the stark forms of winter and the fresh buds and flowers of spring — like a microcosm of the seasons.

In the wider world beyond your doorstep, these changes will be more dramatic and challenging. Unlike city dwellers, animals organize their lives to enable them to follow seasonal cues, whether courting, breeding, nest-building, nesting or feeding their young. In my part of the world, birds like bar-tailed godwits and shining cuckoos make long seasonal migrations to reach our shores. Others, like wrybills and royal spoonbills, migrate internally, but their movements are equally predictable and anticipated by nature lovers.

Wading birds, whether migratory or sedentary species, follow the twice-daily progress of the tides, feeding busily at low tide and roosting on the shore when high tide forces them to rest.

Getting to know how these cyclical patterns play out in your own area is a major task for the serious nature photographer. I've spent hours in the remote south of the country with New Zealand

A silvereye feasts on autumn berries in a city park.

Camera: Canon EOS 7D. *Lens:* EF400mm f/5.6L USM. *Settings:* 400mm f/5.6 1/200 sec ISO 800. © Paul Sorrell

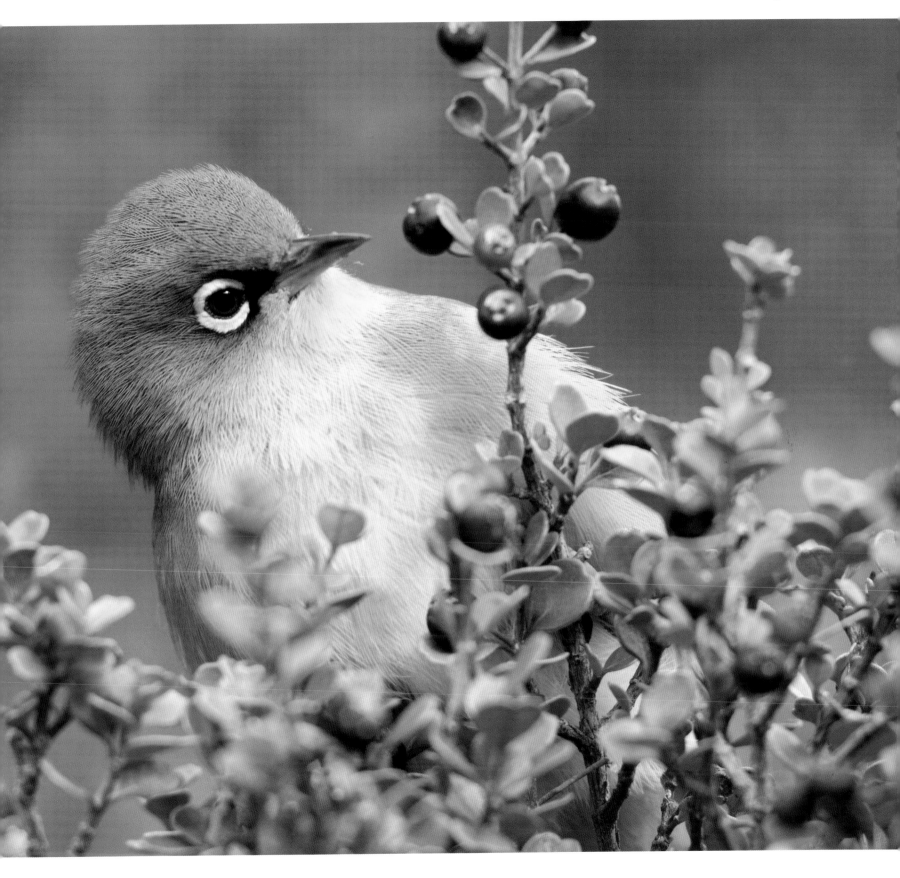

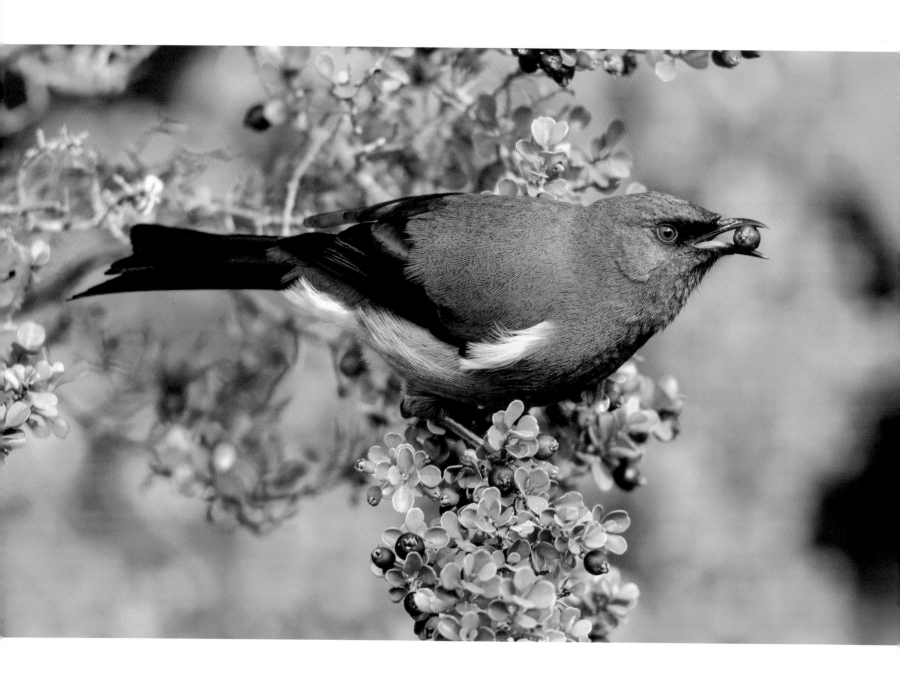

A bellbird plucks energy-rich berries from a
native myrtle tree. Many birds are surprisingly
approachable when feeding.

Camera: Canon EOS 7D. *Lens:* EF400mm f/5.6L USM.
Settings: 400mm ƒ/5.6 1/320 sec ISO 800. © Paul Sorrell

In early spring, female tomtits are gathering material to build their nests. The young are particularly active — and great subjects for photography — in November through to January.

Camera: Canon EOS 7D. *Lens*: EF400mm f/5.6L USM.
Settings: 400mm ƒ/5.6 1/125 sec ISO 800. © Paul Sorrell

dotterels on freezing winter days, catching them before they fly off to their breeding grounds. The brick-red chests of the males are particularly striking as they come into breeding plumage. Local photographers have learned that flight shots of our iconic northern royal albatross are best obtained on days when nor-easterly winds assist them in planing around the cliffs as they land or take off from their breeding colony on a windy headland close to the city.

Birds absorbed in feeding are often quite approachable. Many plants fruit in the autumn and staking out a berry-laden bush or tree where birds are active can produce good results. A few years ago, I made many visits to the same native myrtle tree in my local botanic garden and came away with some satisfying shots of feeding silvereyes and bellbirds, combining action with vivid colour, often in close-up detail.

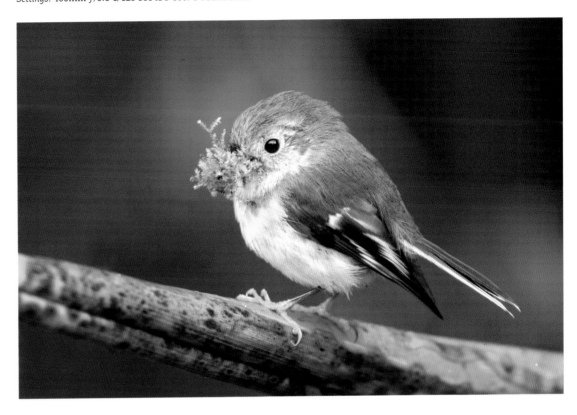

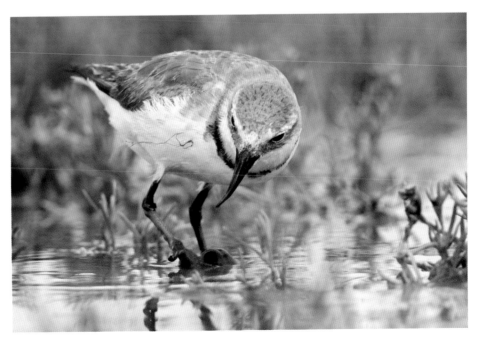

These small waders use a large coastal lake — where I took this photograph — as a staging post on their way to and from their breeding grounds on inland braided rivers. Wrybills are the only birds in the world with a lateral twist to their bills

Camera: Canon EOS 50D. *Lens*: EF400mm f/5.6L USM. *Settings*: 400mm ƒ/8 1/1000 sec ISO 400. © Paul Sorrell.

A pied fantail sings its heart out in my back garden.

Camera: Canon EOS 7D. *Lens:* EF400mm f/5.6L USM.
Settings: 400mm ƒ/5.6 1/250 sec ISO 800. © Paul Sorrell

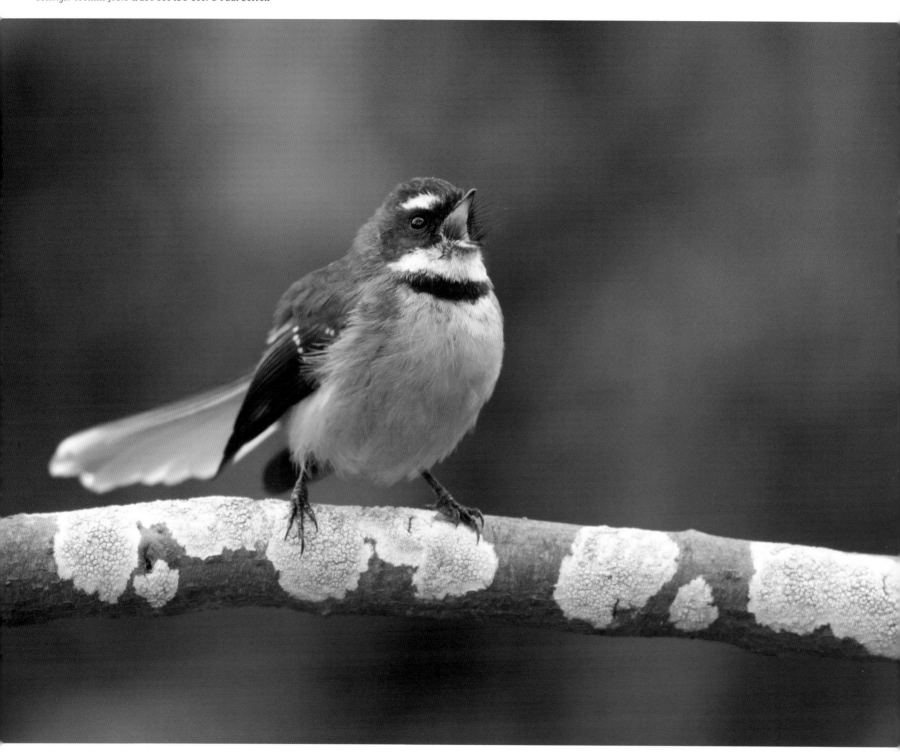

In your own backyard
There's no place like home

TOP TIP Once you have found a suitable perch — well lit, with attractive bokeh (out-of-focus highlights) or interesting foliage — in a spot where the birds are active, don't be tempted to shift your lens onto another target, even if you have to wait a while. Unless of course something extraordinary is happening on the next-door twig. One way to maximize your chances is to keep both eyes open as you peer through the viewfinder.

Sometimes, when I show people an image I've taken recently, they might exclaim, 'What a great shot!' And I might reply, perhaps a little too smugly, 'I shot it from my bedroom window — I didn't even have to leave the house.'

Creating a suitable place to photograph wild birds around your home is a great first step for the budding wildlife photographer. Such a move has many advantages. First, with a little planning you can create an environment that comes closer than anything else to an outdoor studio (see pp. 30–33). Second, it can be as simple or as elaborate as you care to make it. And, finally, because there's no need for you to leave home, you can use your setup anytime the mood takes you.

In my case, I'm lucky that my setup comes ready-made in the shape of a native kōwhai tree on the lawn behind my 1908 wooden villa in the suburbs. By standing on the veranda, or setting up my tripod in the bedroom and shooting through the sash windows, I can focus on a variety of attractive lichen-encrusted branches and twigs where I hope my avian subjects will settle. Shooting from indoors is the ultimate in comfort — you can even pull up an easy chair …

Having arranged your 'studio', the next challenge is to attract your quarry. Here there are a variety of approaches. Sometimes I use playback, with the speaker sitting close to my target perch, or I use food as bait. In New Zealand, a simple container of sugar-water will attract our three native honeyeaters: tūī, bellbirds and silvereyes. More elaborate feeders offering fat, seeds and nuts will draw a variety of small birds including finches and (in Europe, for example) warblers and woodpeckers.

If your garden lacks suitable natural perches, then you can easily make your own setup. This might be as simple as a couple of stakes driven into the ground, one holding a feeder and the other with a photogenic branch or

foliage attached. Arrange the perch so that hungry birds will alight on it — albeit briefly — before proceeding to the feeder. Position your feeding station close to a place that offers some concealment, such as a garden shed. And be aware of the background and direction of the light — you can often change your position to get the result you want.

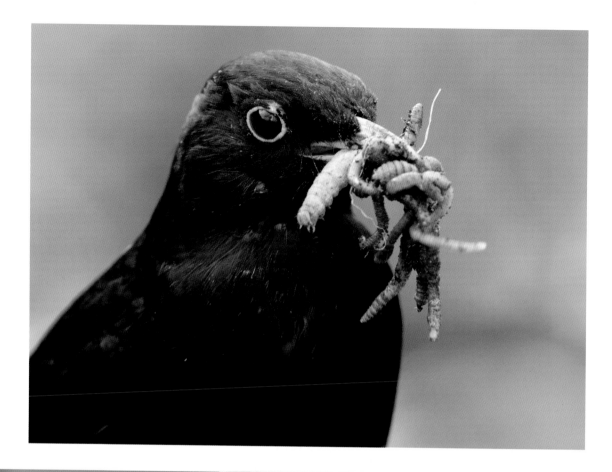

This grey warbler was photographed from my bedroom window.

Camera: Canon EOS 7D. *Lens:* EF400mm f/5.6L USM. *Settings:* 400mm ƒ/5.6 1/320 sec ISO 800. © Paul Sorrell

This blackbird collected many beakfuls of worms and insects for its young as I spread compost on my vegetable plot.

Camera: Canon EOS 50D. *Lens:* EF400mm f/5.6L USM. *Settings:* 400mm ƒ/6.3 1/60 sec ISO 400. © Paul Sorrell

HANDY HACK

Autumn leaves can be used in at least two ways: as part of the foreground, adding texture and shape as well as bold colour; or (if sufficiently distant) to provide an orange–red blur that will provide your subject with an attractive backdrop.

Distant autumn leaves provide a colourful backdrop for a pair of silvereyes in my backyard.

Camera: Canon EOS 7D. *Lens:* EF400mm f/5.6L USM. *Settings:* 400mm *f*/5.6 1/250 sec ISO 800. © Paul Sorrell

Know your patch
Taking the next step

When I was a postgraduate student at Cambridge University in the 1970s, my local patch was a scrap of woodland on the River Cam on the outskirts of the town, about ten minutes' walk from home. Here I would delight in small flocks of siskins feeding on alder catkins, listen out for the first chiffchaff of spring and raise my binoculars to spot foraging lapwings and snipe hunkered down in the wet meadows across the river.

I would visit my special spot as often as I could, not knowing what I might see and grateful for the chance to clear my mind and senses after hours of study in the university library.

All serious birders have a local patch that they keep an eye on. It can be the park at the end of your street, a piece of urban wasteland or even your own backyard — although a birding 'patch' is usually somewhere further afield.

FINDING A PROJECT

Having a photo project on the go is another way of exploiting the potential of your patch. The experience you have built up over time will allow you to become familiar with a number of species, anticipate their behaviour and choose the spots where the light and backgrounds will be most suitable. Regular visits over many years to Orokonui Ecosanctuary near my hometown have put me on intimate terms with the local birdlife. I've taken a special interest in the tomtit population that thrives there, observing them throughout the year and managing to photograph females as they collect material for nest-building and playful fledglings making their first forays away from the nest.

A young tomtit tentatively explores its forest world.

Camera: Canon EOS 7D. *Lens:* EF400mm f/5.6L USM. *Settings:* 400mm ƒ/5.6 1/100 sec ISO 800. © Paul Sorrell

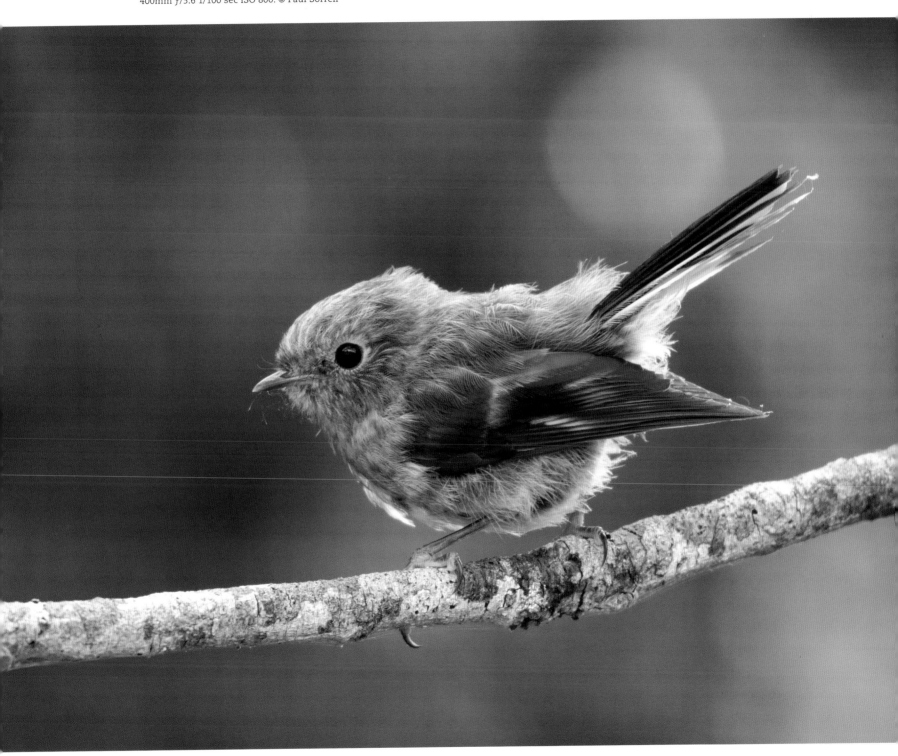

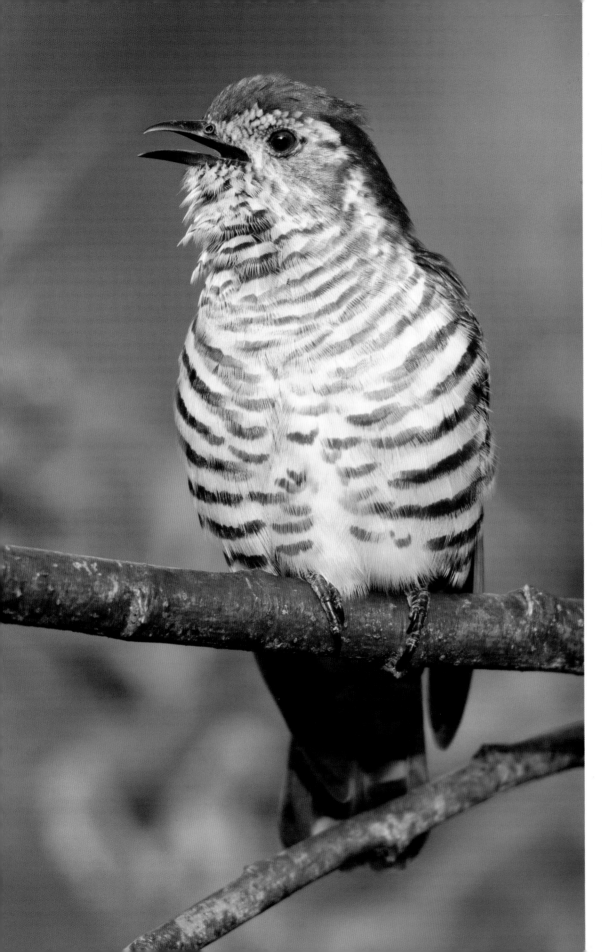

Each spring, shining cuckoos arrive in New Zealand from their wintering grounds in Papua New Guinea and the Solomon Islands.

Camera: Canon EOS 50D. *Lens*: EF400mm f/5.6L USM. *Settings*: 400mm f/5.6 1/400 sec ISO 400. © Paul Sorrell

Wherever it is, there are many reasons for visiting your patch regularly, in all weathers and throughout the year. It will contain resident birds that you will get to know very well. Weeks may pass in which nothing seems to change, but the march of the seasons will deliver a fresh avian cast, adding new actors to the old line-up. If you are lucky enough to live on a migration route, passage migrants may well drop in, often staying no longer than a few days. You'll be surprised — and occasionally thrilled — by the rarities you'll encounter. And the commoner birds will show changes in behaviour and movements of their own as spring arrives or colder weather sets in.

Keep a journal of your visits, noting interesting behaviour as well as fluctuations in numbers. If you do this year after year, patterns will emerge which will enrich your birding and photography. In addition, your observations will potentially contribute to knowledge of wildlife in your area.

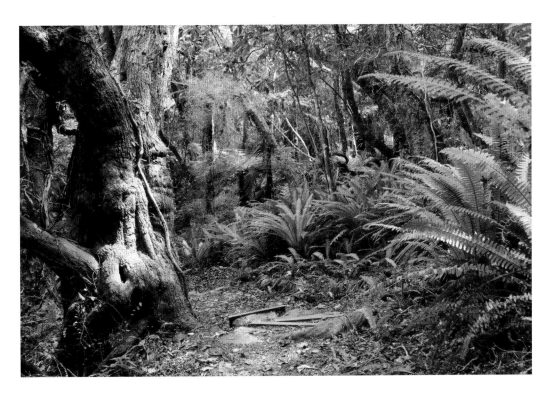

If your subject is large in the frame, choose the upper centre focus point and place it on the bird's head or eye to avoid cutting off its feet! By half-depressing the shutter button you can move the lens and alter your composition before taking the shot while retaining focus.

Podocarp forest at Orokonui Ecosanctuary. About 20 minutes' drive away from my home, this ecologically rich reserve, protected by a predator-proof fence, has become my local patch.

Camera: Canon EOS 7D. *Lens*: EF28-135mm f/3.5-5.6 IS USM. *Settings*: 30mm f/8 1/50 sec ISO 800. © Paul Sorrell

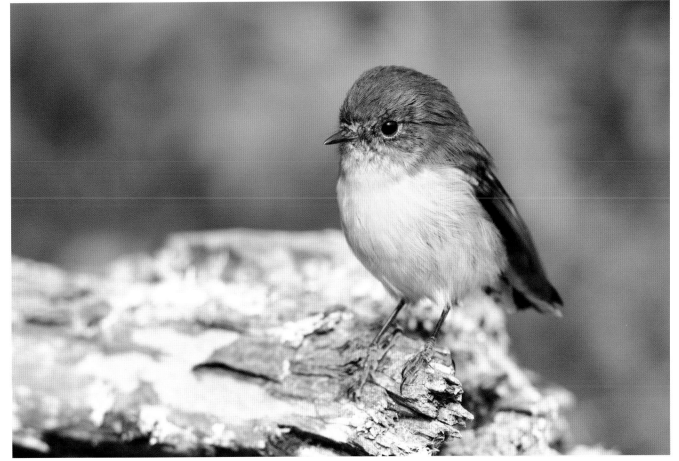

Photographing tomtits in my local nature reserve has been a long-term project for me.

Camera: Canon EOS 7D. *Lens*: EF400mm f/5.6L USM. *Settings*: 400mm f/6.3 1/640 sec ISO 400. © Paul Sorrell

Taken
The Bung-eye story

The wildlife reserve near my town contains plenty of good spots for photographers, and over the winter of 2018 my 'photo buddy' Neale and I made one small clearing a regular stopping place. Encircled by young cabbage trees, and with plenty of low shrubbery, it offered a good variety of cover and perches for birds. Unlike in the forest, there was room for us to move around and light overhead. On the best days for photography, the mellow winter sunlight was filtered by a high screen of cloud, creating a softbox effect.

And the birds collaborated. Small parties of twittering fantails regularly invaded the clearing, and the grey warbler's high-pitched floating melody accompanied our sessions. Then, one Saturday morning, we were delighted to find that a pair of tomtits had taken up residence.

Tomtits hunt in a predictable pattern, using the same low perches as they spy out insects and other small invertebrates on the ground. This was ideal for us as photographers, enabling us to set up our tripods and long lenses in advance of their arrival at a particular perch.

At first, our attention fell on the female, with her delicate lemon breast and muted colours. On one day when the light was particularly beautiful, she posed on a lichen-decked stump, paused in a makomako (wineberry) tree and landed, featherlike, on stalks of grass. Later, we noticed the showier male bird, whom we named Bung-eye, as he was obviously blinded in his right eye. This caused us a few problems as, although we could follow him on his hunting round easily enough, we were constantly forced to manoeuvre so as to capture his 'good side'.

Nevertheless, Bung-eye proved a very cooperative subject, alighting on the cabbage trees and coprosma and mānuka bushes and even fossicking for worms after heavy rain. Every half hour or so, he would pause and let out an abrupt, piercing call. Then he and his mate would briefly come together before resuming the hunt, she in a neighbouring patch that was mainly woodland.

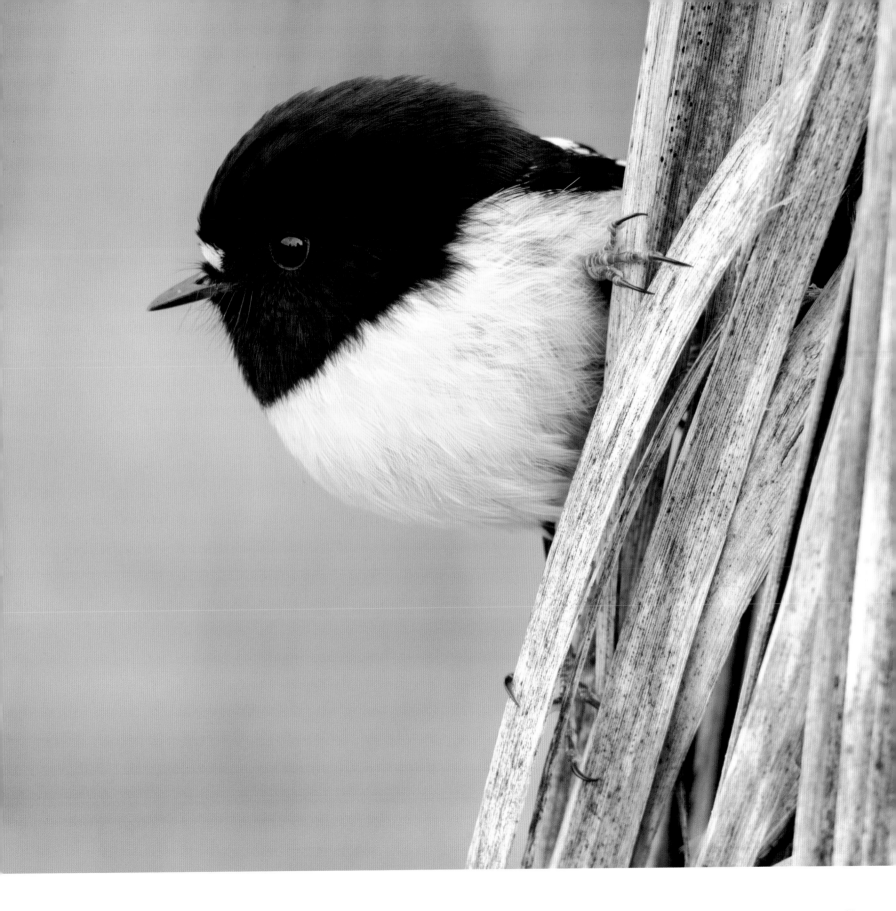

Although on our weekend visits we now scarcely saw the female, Bung-eye was always to be spotted on his rounds. We even put up a small natural perch in a position that enjoyed good light and a pleasing background.

But our avian idyll was to change dramatically and unexpectedly. One morning when I was in the clearing on my own, waiting beside our bespoke perch, out of the corner of my eye I saw a large bird swoop towards the ground just a few feet to my right. It was a falcon, clasping a small bird in both its talons. Realizing that I wasn't in fact a tree, it had thought better of landing and flew off into the trees beyond the aviary.

We knew there were falcons about. Ecosanctuary staff had told us they had seen them perched in the kānuka branches above the feeder opposite

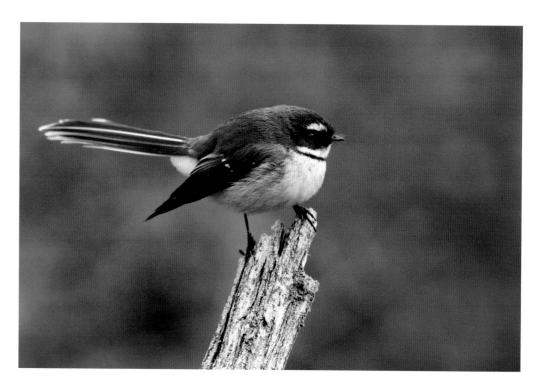

Groups of pied fantails are often seen in the clearing.

Camera: Canon EOS 7D. *Lens:* EF400mm f/5.6L USM. *Settings:* 400mm ƒ/6.3 1/250 sec ISO 640. © Paul Sorrell

Bung-eye's mate was small and delicate enough to alight on a grass stem.

Camera: Canon EOS 7D. *Lens:* EF400mm f/5.6L USM. *Settings:* 400mm ƒ/6.3 1/160 sec ISO 640. © Paul Sorrell

(Previous page) Bung-eye the one-eyed tomtit on his regular hunting round. We took pains to photograph him showing his best side.

Camera: Canon EOS 50D. *Lens:* EF400mm f/5.6L USM. *Settings:* 400mm ƒ/6.3 1/100 sec ISO 640. © Paul Sorrell

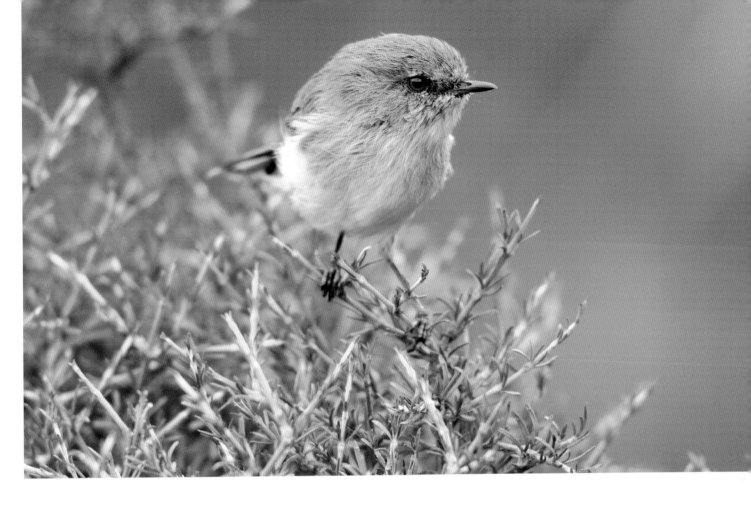

Grey warblers are commonly seen and heard in gardens, scrub and woodland.

Camera: Canon EOS 7D. *Lens:* EF400mm f/5.6L USM. *Settings:* 400mm ƒ/5.6 1/250 sec ISO 1000. © Paul Sorrell

the aviary, attracted by the small birds that gather there, and we had come across circles of feathers in the clearing — just where I'd been standing — that marked it as a falcon plucking site.

From that moment, we never saw Bung-eye again. Once, we had a glimpse of his newly widowed mate, chasing the neighbouring tomtit pair as if she wanted to make up a threesome. I reflected that if *I* could follow Bung-eye's progress with relative ease, how much easier would it be for a fleet-winged raptor to anticipate his movements and lunge in for the kill? Being literally blindsided would only have hindered his survival chances.

Although Bung-eye had almost become an old friend to both of us, there was little point in mourning his demise. Nature is many things, but never sentimental. With the loss of our tomtit pair, the clearing, once a favoured hunting ground for birds and photographers alike, fell silent. At first I feared that the falcons might have cleaned everything out. I had heard that a pair was now nesting in the sanctuary and, on one level, this was wonderful news. But it would be a great irony if Orokonui, elaborately fenced off so as to exclude four-legged predators, was to suffer depradation through attacks from above.

A year later, the clearing is once again alive with birds. The tomtits have returned and robins are often seen here as they expand their territories across the sanctuary. I have seen falcons flying overhead and last summer, in another part of the reserve, a falcon flew out of the forest and streaked along the gravel path, its sleek brown form a compact bundle of pure energy and unswerving purpose. Although I didn't manage to take a photograph, its image was exposed on my retina and is stored permanently in my memory. How could I fail to welcome such a magnificent visitor?

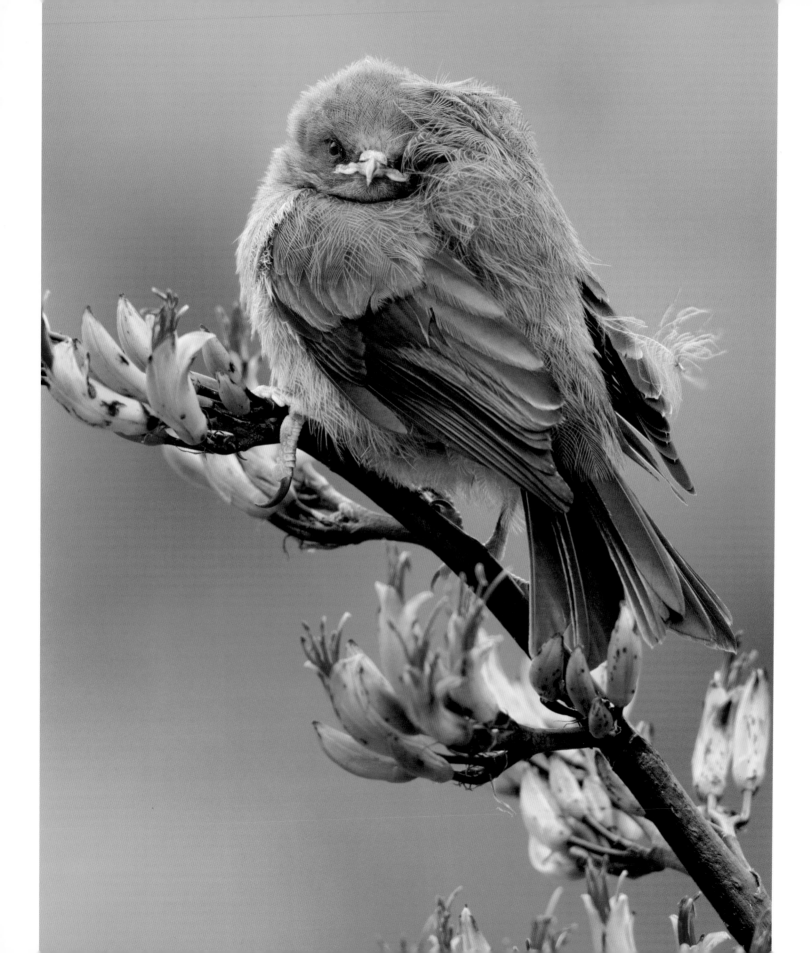

Creating an outdoor studio
Lights, camera, action!

Like studio portraiture, successful wildlife photography is all about creating an environment where as many technical elements as possible are under your control — especially the 'big three' of lighting, background and composition.

Lighting is probably the first variable to consider. Do you prefer front lighting (which gives the most even illumination), side lighting (to show up texture and detail) or perhaps back lighting (which can be tricky to manage, but can produce some attractive effects)?

Next, having considered the direction of the light, you want to isolate the bird by setting it on a perch where the background will be pleasingly blurred, so that the subject 'pops'. So far, so good.

Finally, you need to think about composition. How do you want the bird to appear in the frame? Do you favour a classic portrait, with the subject sitting pertly on one of the 'thirds' (see 'The rule of thirds', p. 70), its head slightly turned to meet the viewer's eye, and with plenty of space in the frame for it to look into? Or do you want a coveted group shot, or to capture the even rarer sight of mum feeding her young? Or perhaps you want to freeze the moment of take-off or landing. Of course, these are ideal scenarios — the hardest part is to encourage your subject to place itself exactly where you want it!

The possibilities are legion, but what you eventually photograph will depend on your fieldcraft and knowledge of animal behaviour as much as your camera skills.

This juvenile bellbird appears to be taking a nap.

Camera: Canon EOS 7D. *Lens*: EF400mm f/5.6L USM. *Settings*: 400mm ƒ/6.3 1/320 sec ISO 400. © Paul Sorrell

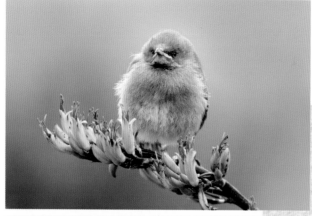

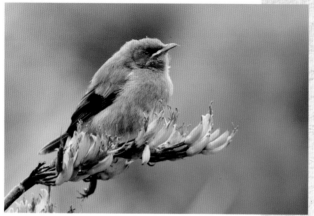

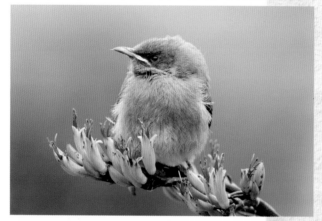

A MODEL SUBJECT

Sometimes you are lucky enough to have a co-operative subject. This juvenile bellbird, feeding on native flax flowers, seemed unperturbed as two photographers circled around it, enjoying the luxury of being able to choose a variety of shooting positions and camera angles over an extended period. Although it sometimes flew off, it always returned to the same plant, offering further opportunities for the perfect portrait. Like most young birds, it showed no signs of fear, despite being the centre of attention.

The parent birds were also in attendance, bringing it extra food from time to time. The summer light was perfect — bright but soft under a haze of cloud. In between feeding sessions, our baby bellbird would tuck one wing over its face as if taking a nap!

Rarely does a wildlife photographer get the chance to take a whole sequence of shots in a calm, controlled manner, moving around the subject at will. Enjoy it when it happens to you!

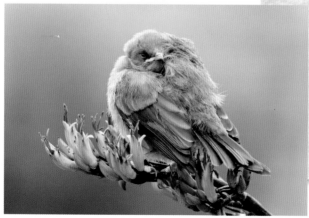

A bellbird fledgling flirts its tail for the camera.

Camera: Canon EOS 7D. *Lens:* EF400mm f/5.6L USM.
Settings: 400mm *f*/6.3 1/500 sec ISO 1000. © Paul Sorrell

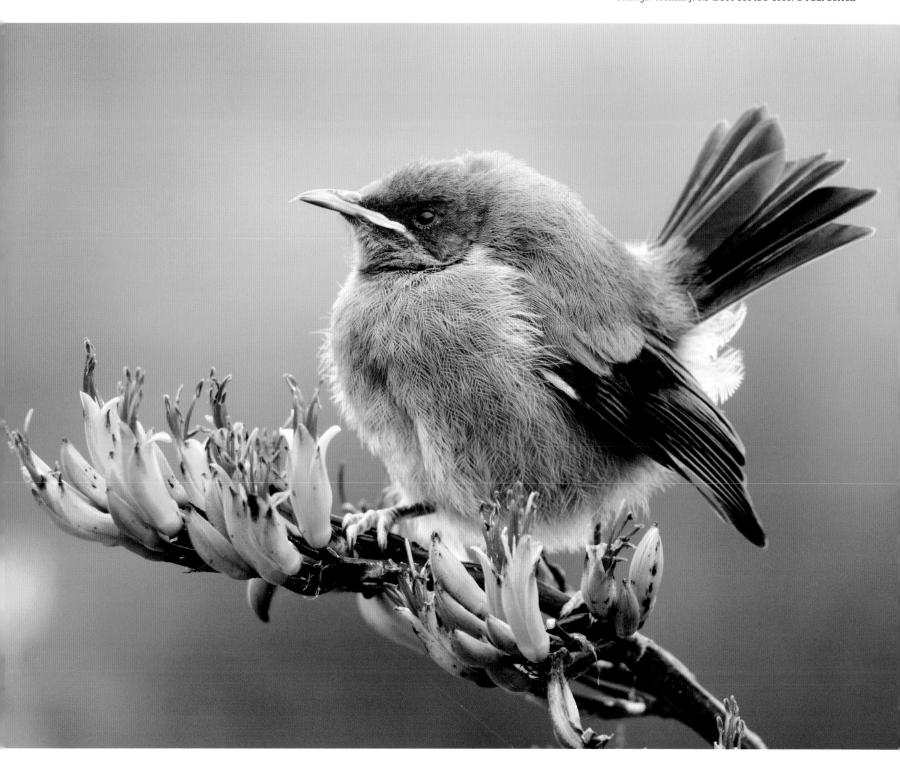

Birds in the city
Opportunities are everywhere ...

You don't have to travel to 'unspoilt' areas of countryside to take vibrant and convincing wildlife photographs. Many birds have made urban areas their home, even to the extent of being reflected in their names — house sparrow, barn swallow, house martin. In the United Kingdom, the black redstart colonized bomb sites after World War II and is now almost exclusively found in urban environments, especially derelict buildings (which are disappearing fast as the result of urban regeneration).

Water, trees and open areas are found in abundance in many cities. Increasingly, patches of weeds and wildflowers are being left to thrive at the edges of manicured parks and gardens. Cemeteries, with their often overgrown corners and mature trees, are also good places for birds. In great cities like London and Rome, even seemingly inhospitable environments like skyscrapers have become home to peregrine falcons, which nest on cliff-like ledges and catch abundant feral pigeons to feed their chicks.

And several European cities play host on winter evenings to vast, swirling 'murmurations' of starlings as they settle to roost. These mass displays offer wonderful opportunities for photographers as the flocks constantly form and reform, creating fascinating shapes in the sky.

City birds can be quite approachable, especially in areas where there is heavy foot traffic like public parks and botanical gardens. Sometimes it is useful to show the urban environment in your photos but, if you want to present your subject in a neutral setting, then with a little bit of ingenuity and manoeuvring (so as to avoid having signs and lampposts in the background), you can achieve this. For example, try taking pictures of waterfowl in the duckpond in your local park by lying as close to the water as you can get and shooting them as they swim towards you. The results can be terrific.

Londoner David Lindo has become famous as the Urban Birder. His philosophy is simple: 'Anyone can become an Urban Birder. You can do it anywhere and any time, whether you've got the day to spare, on your way to work, during your lunch break or just looking out of a window. Look up and you will see.' On his website (theurbanbirder.com), David lists some urban birding tips to get people started: 'See your urban environment as how a bird would: The buildings are cliffs and any green areas are an oasis for nesting, resting and feeding. Don't stress about learning the names and songs of all the birds you encounter, just enjoy them. Learn at your own pace.'

A pair of welcome swallows sit on an ornamental feature in the duck pond at my local botanic gardens. The birds were nesting in a small wooden structure nearby and were very approachable. Perhaps the few feet of water between me and the birds made them feel secure enough to relax.

Camera: Canon EOS 50D. *Lens*: EF400mm f/5.6L USM. *Settings*: 400mm ƒ/8 1/250 sec ISO 400.
© Paul Sorrell

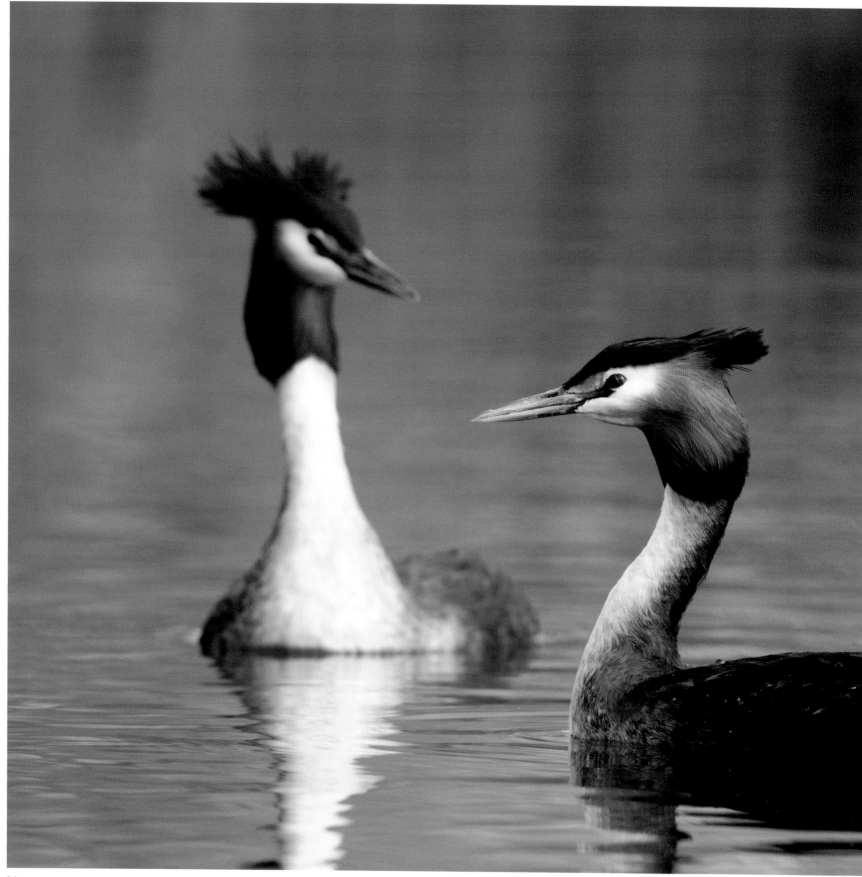

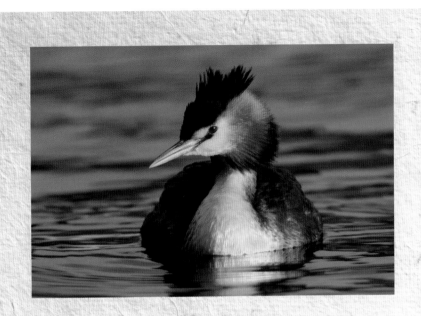

A TALE OF SUCCESS AGAINST THE ODDS

Birds can thrive even in the most unpromising settings. Where I live, Australasian crested grebes (as southern great crested grebes are called) are mostly confined to inland lakes in the south. A few pairs, however, have made their home in a most unlikely setting, a former gravel pit that has been developed into a recreational reserve next to one of the country's busiest airports. This urban wetland on the edge of the city is alive with noisy vehicles, jet skis and water polo players — even dragon boat racing — but it hasn't stopped a handful of these charismatic birds nesting here and producing young.

Great crested grebes on an urban lake.

Camera: Canon EOS 7D. *Lens:* EF400mm f/5.6L USM. *Settings:* 400mm ƒ/6.3 1/1600 sec ISO 800. © Paul Sorrell (left)

Camera: Canon EOS 7D. *Lens:* EF400mm f/5.6L USM. *Settings:* 400mm ƒ/6.3 1/125 sec ISO 800. © Paul Sorrell (above)

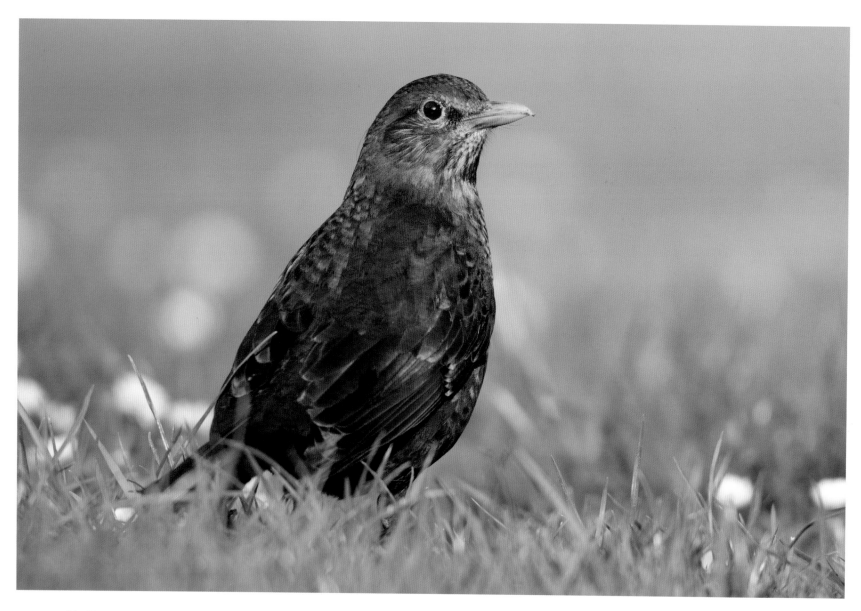

European blackbirds are common
in city parks and gardens.

Camera: Canon EOS 50D. *Lens:* EF400mm
f/5.6L USM. *Settings:* 400mm ƒ/5.6 1/160
sec ISO 400. © Paul Sorrell

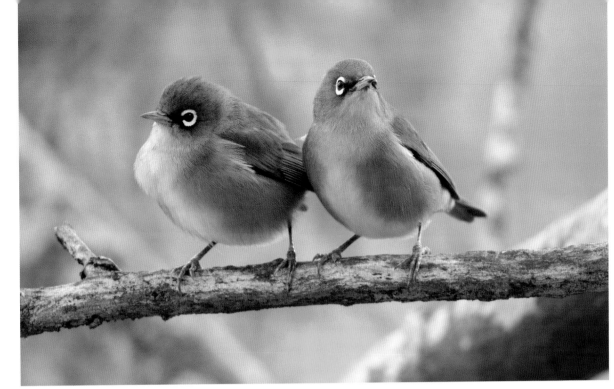

A pair of silvereyes
in my back garden.

Camera: Canon EOS 7D.
Lens: EF400mm f/5.6L
USM. *Settings*: 400mm
f/5.6 1/250 sec ISO 800.
© Paul Sorrell

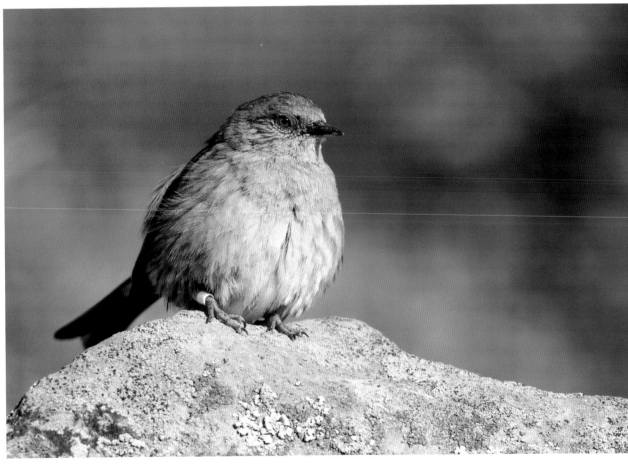

The European dunnock or
hedge sparrow is a familiar
bird to town dwellers.

Camera: Canon EOS 7D. *Lens*:
EF400mm f/5.6L USM. *Settings*:
400mm *f*/5.6 1/1000 sec ISO 400.
© Paul Sorrell

Expect the unexpected
Anything can happen, and it probably will ...

Nature never fails to surprise me. You can plan a shooting session or expedition down to the last detail — and, in general, this is the way to get good shots — but nature may have other plans. The scene that unfolds before you in the field may be very different from what you anticipated. Sometimes, in the same place and under identical conditions, the birds will be active and numerous, and another day you won't see as much as a tail feather.

Of course, there may be good reasons for this. Several year ago, when my local photographic society was hosting a national conference, I led a field trip to photograph one of our iconic species — yellow-eyed penguins. I knew a place not far out of the city where they were guaranteed to come ashore in the late afternoon after a day feeding at sea — a low headland overlooking a boulder-strewn beach where I had hunkered down during many successful trips.

But this day — nothing. The group of dedicated wildlife photographers I was responsible for lay as still as the surrounding rocks for hour after hour. The odd penguin head bobbed up on the horizon, but no birds came ashore. Then we discovered why — a pair of sea lions was patrolling the surf, on the lookout for an opportunistic meal. As the light faded, we made our way back along the beach, where we managed to soften our disappointment by photographing a young bird, hungry and perplexed by the non-appearance of its parent with a crop full of fish. Seeing the sea lion pair sparring photogenically as we swung onto the track for home left us with mixed feelings.

The New Zealand sea lion pair responsible for disrupting a penguin photography expedition.

Camera: Canon EOS 50D. *Lens*: EF400mm f/5.6L USM. *Settings*: 400mm f/6.3 1/200 sec ISO 400. © Paul Sorrell

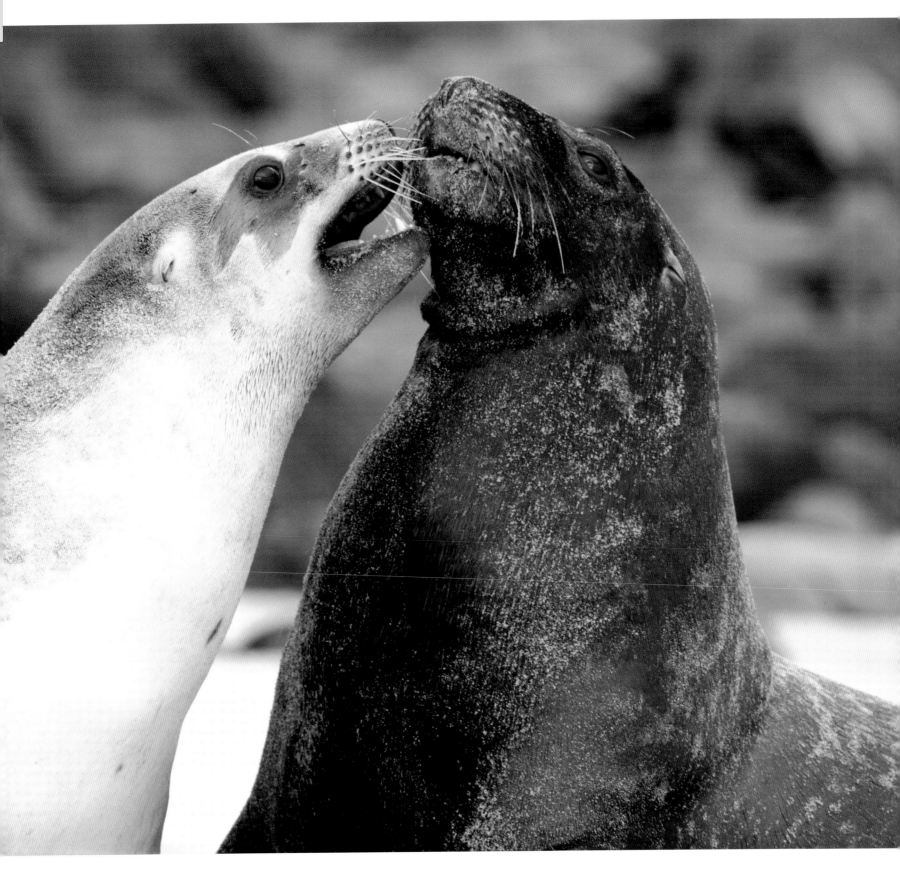

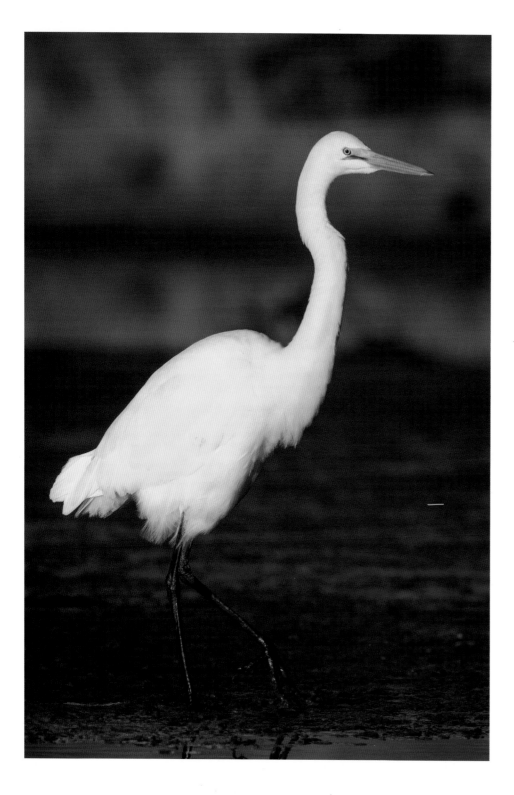

But sometimes the unexpected can be overwhelmingly positive. Crawling up to a group of roosting pied oystercatchers — what seemed like a consolation prize at the time — is one example (see p. 91). More astonishing still was my encounter with a white heron at the edge of a lagoon. I was lying in a bed of coarse grasses, as close as I could get to the waterline without getting wet, waiting for something to come within range of my lens. Suddenly a majestic bird landed soundlessly in front of me, apparently unconcerned about my presence. It was so close that I couldn't fit its whole body in the frame — the best I could do was a vertical shot (see p. 11).

The lesson is a simple one. The most extraordinary creatures can literally drop right in front of you if you are at the right place, keeping quiet and low and receptive to what's going on around you — nature's endless dance.

I had a magical encounter with this white heron or kōtuku at a local wetland.

Camera: Canon EOS 7D. *Lens:* EF400mm f/5.6L USM. *Settings:* 400mm ƒ/7.1 1/1250 sec ISO 200. © Paul Sorrell

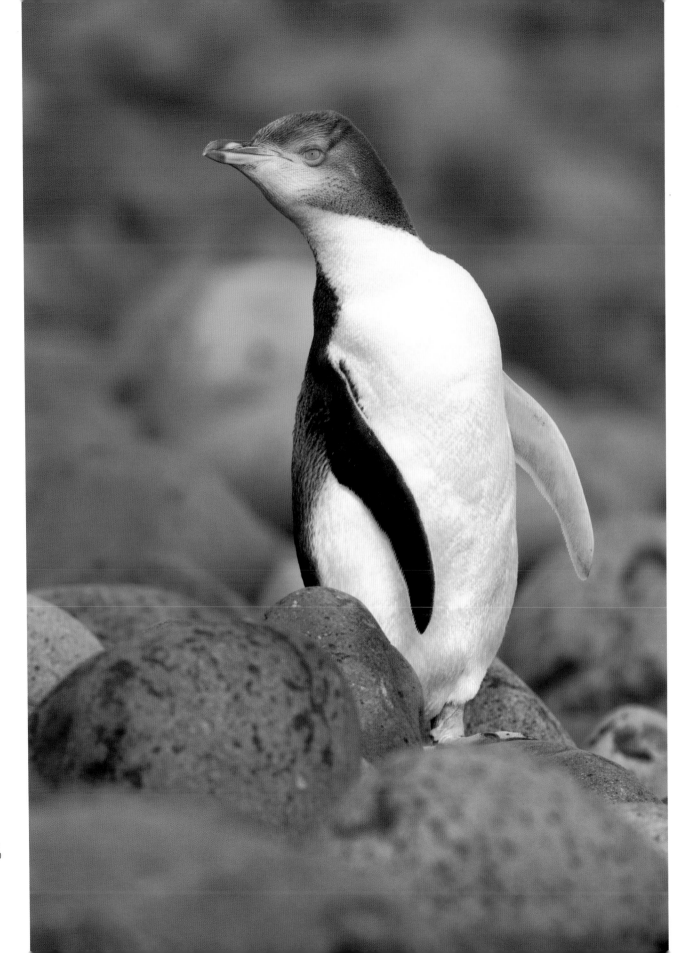

This juvenile yellow-eyed penguin hopped down to the rocky shore when its parent failed to arive with a meal of fish.

Camera: Canon EOS 50D.
Lens: EF400mm f/5.6L USM.
Settings: 400mm ƒ/5.6 1/800 sec ISO 400. © Paul Sorrell

A piece of camouflage netting is a simple but effective way of disrupting your outline in the field.

New Zealand dotterels are less wary than many wading birds, but still require a cautious approach. This individual was photographed beside a communal roost at high tide.

Camera: Canon EOS 40D. *Lens:* EF400mm f/5.6L USM. *Settings:* 400mm *f*/6.3 1/800 sec ISO 400. © Paul Sorrell

Making yourself inconspicuous
Keeping a low profile will increase your chances of success

Wild animals should be approached slowly, cautiously and always with respect. Often this is enough to gain your subject's confidence and get close. Taking advantage of natural cover will often help — trees and shrubs, long grass, slopes and hollows, or hunkering down on a low headland so as not to frighten penguins coming ashore.

Wearing drab — and preferably rustle-free — clothing in the field is a must, and a broad-brimmed hat will shade your eyes as well as helping to conceal your face. You might even consider such refinements as camouflage tape or rubber tubing that can be used to disguise your lens barrel.

Many birds will take flight at your approach, so obscuring your human outline is important. Lying prone at the edge of a lake or coastal site, or crawling along a beach towards your quarry will achieve this goal, as well as bringing you down to eye-level with the birds. For a little extra concealment, it's worth investing in a square of camouflage fabric, available from hunting shops — enough to drape over your body and camera.

The next stage is to build or purchase a hide or blind. A length of camo fabric draped over a few sticks pushed into the sand may be enough to fool sacred kingfishers hunting crabs at low tide, but a more reliable alternative may be a simple pop-up hide that is easy to carry and folds into a lightweight disc. These can be purchased online, as can a variety of larger dome hides and bag hides that you can pull over yourself and your gear. If you are handy enough, it's possible to make a simple but effective floating hide — to be used with fishermen's waders or wetsuits — that can get you very close to waterbirds like grebes.

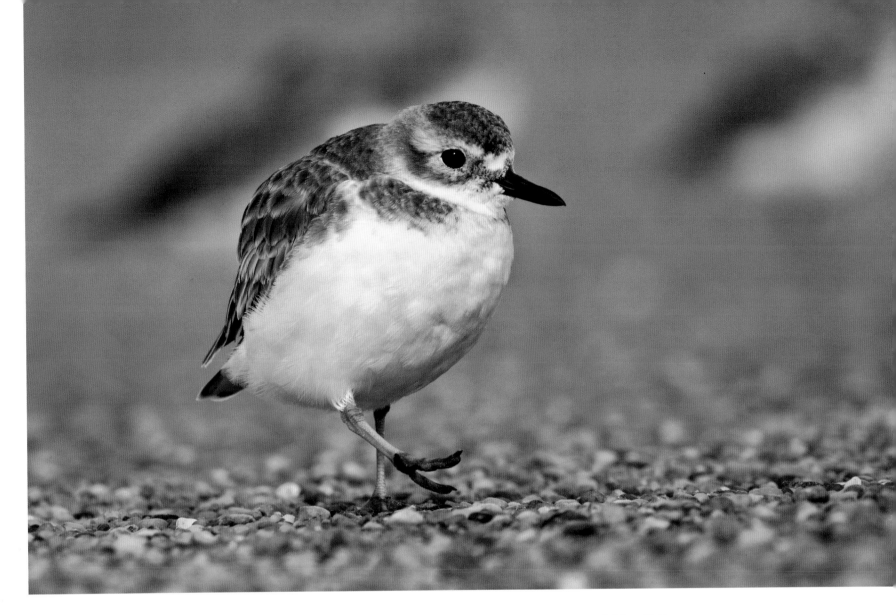

A hide is an essential accessory when photographing shy birds of prey like eagles or, in my part of the world, the Australasian harrier. You will need to set up somewhere where the light and background are good, source some tasty bait like a road-killed possum or rabbit, install yourself in your shelter, and wait … A few home comforts like a thermos of tea and a picnic chair, or even a sleeping bag, will ease the long hours you may have to spend in a cramped shelter to get the results you want.

If all this sounds too strenuous, then a car makes a good mobile blind. A vehicle can be very useful when photographing waterbirds like herons and spoonbills, where the road passes close to their habitat. Take a beanbag to drape over your wound-down window; a roll of foam plastic with a slit cut along it will also support a long lens.

Fieldcraft tips

Getting close to shorebirds and waders requires special patience. If at low tide you spot a group of spoonbills working along a channel, then a useful trick is to lie down (preferably in a spot that's not too muddy) in their line of advance. To photograph a group of banded dotterels resting at high tide, a different approach is called for. Try crawling towards the birds slowly, pushing your gear ahead of you, stopping every few metres to allow them to get used to your presence.

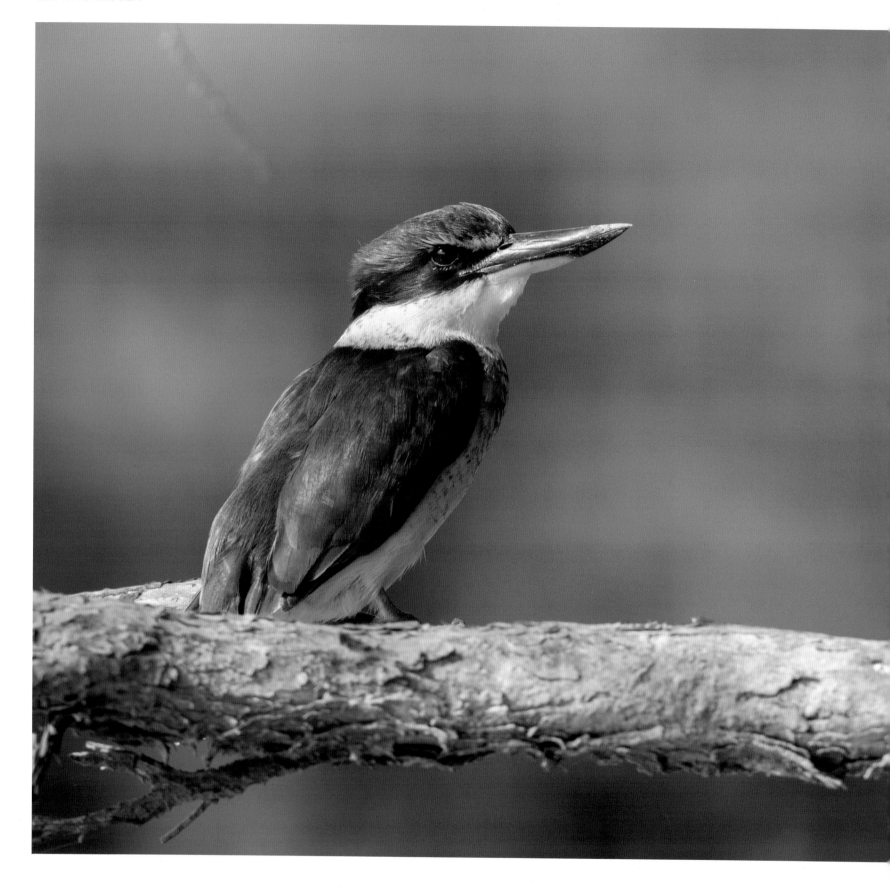

TOP TIP Birds may be observant, but they can't count! If they see a person walking into a hide, they may become wary and not approach you. The answer is to ask a friend to accompany you to the hide, and then have them walk away on their own. It fools them every time!

To a bird, pale hands, busy working camera dials, can seem like a writhing, multi-limbed creature. If your hands are scaring the birds away, then wear dark gloves that are thin enough to allow you to operate your gear — polyprops are ideal.

Every photo has a story behind it. With the tide well out, my 'photo buddy' and I arrived at a broad coastal bay near the city and set up our pop-up hides in front of a tree where we had seen sacred kingfishers landing on a previous visit. After waiting for what seemed like an age, we discovered that the only kingfisher in the vicinity was sitting in a tree behind us, observing us intently. After still more waiting, my companion left to fetch some more gear, inadvertently flushing the bird onto 'our' branch. I got the shot, while he missed out. That's wildlife photography for you!

Camera: Canon EOS 7D. *Lens*: EF400mm f/5.6L USM. *Settings*: 400mm ƒ/6.3 1/640 sec ISO 400. © Paul Sorrell

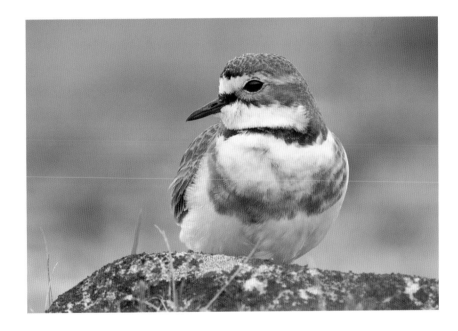

I captured this banded dotterel on its upland breeding grounds. Great care should be taken when photographing near nests.

Camera: Canon EOS 50D. *Lens*: EF400mm f/5.6L USM. *Settings*: 400mm ƒ/8 1/160 sec ISO 400. © Paul Sorrell

Keeping safe
Respecting the elements is an essential part of fieldcraft

Just as photographers take pains to protect their valuable equipment, so we need to take care of ourselves in the field. Our basic needs are not too hard to meet. I always leave room in my pack for food and water and make sure that I'm dressed for the conditions. As you may find yourself wading through head-high foliage or fording streams, wear a waterproof coat and sturdy footwear, preferably hiking boots for wet or rough country. Avoid gumboots, as they will chafe your feet over even moderate distances.

Always check the weather forecast — not just for suitable lighting conditions, but to avoid bad weather, especially in exposed environments like mountains. Plan your route in advance using reliable maps. On a recent trip to a remote rural area, my 'photo buddy' Neale and I were stranded when Google Maps led us down a farm track that became impassable and eventually disappeared altogether. And unless you have an all-terrain vehicle, it's best to keep to the roads.

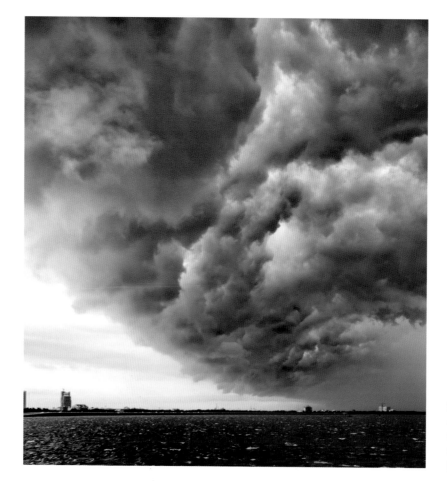

Be prepared for a sudden change in the weather when photographing birds like the kea in its alpine habitat.

Camera: Canon EOS 7D. *Lens*: EF400mm f/5.6L USM. *Settings*: 400mm ƒ/7.1 1/640 sec ISO 800. © Paul Sorrell

(This page and opposite) An approaching storm or rapidly rising tides can catch the unwary photographer off guard.

48

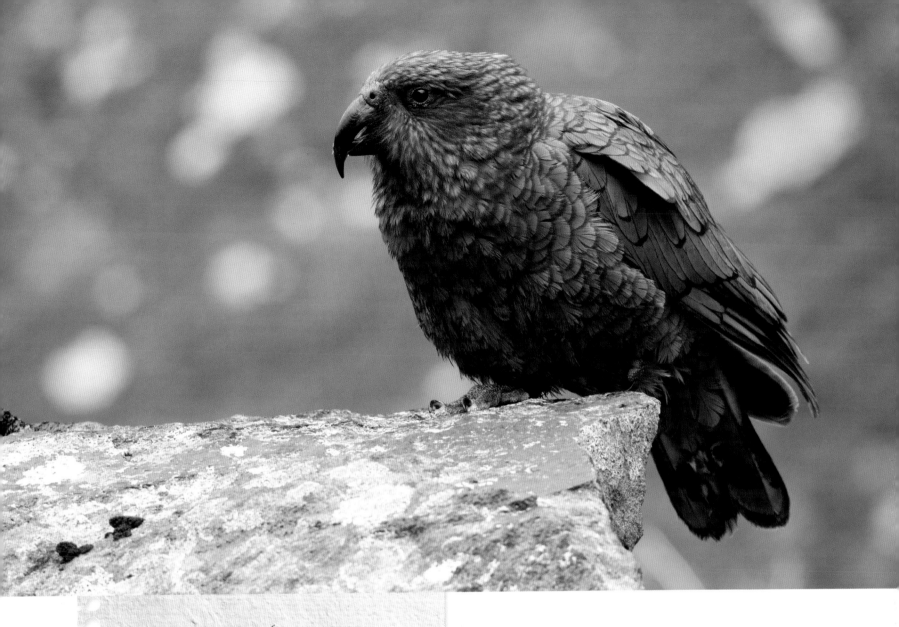

TAKE CARE OUT THERE

When working in unfamiliar environments, and especially when photographing dangerous animals like polar bears, Israeli photographer Roie Galitz always has a local guide to keep an eye on him. 'You cannot engross yourself in photography and keep on top of your safety; it's so important that someone else has your back.'

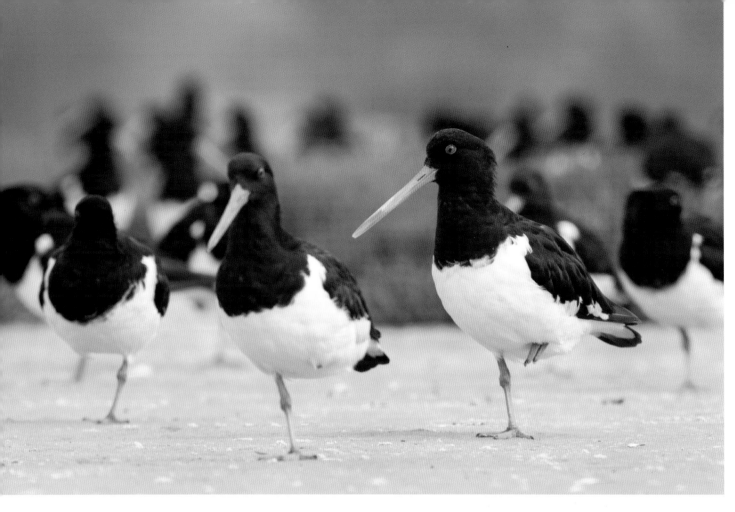

A group of South Island pied oystercatchers take a break from feeding at the high-tide roost. I had to crawl over muddy sand to get close, and then beat a hasty retreat as the tide rose all around me.

Camera: Canon EOS 7D. *Lens:* EF400mm f/5.6L USM. *Settings:* 400mm f/8 1/500 sec ISO 400. © Paul Sorrell

This bar-tailed godwit alighted briefly when I was hunkered down among New Zealand dotterels as they roosted on a sand bank at high tide.

Camera: Canon EOS 7D. *Lens:* EF400mm f/5.6L USM. *Settings:* 400mm f/6.3 1/1000 sec ISO 400. © Paul Sorrell

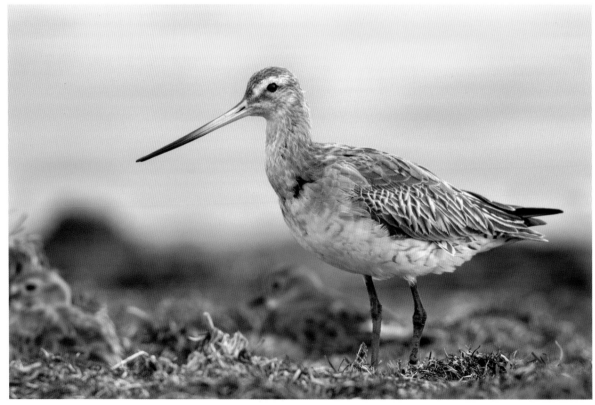

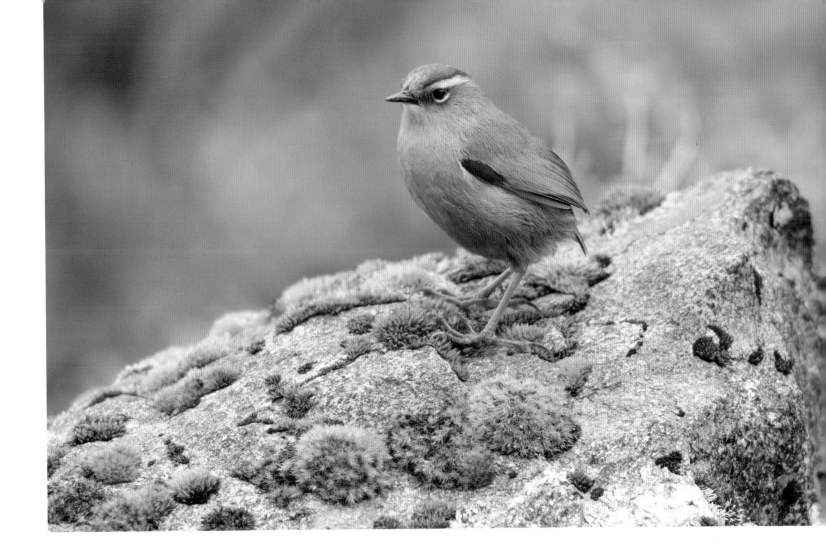

Once you reach your destination, stay on or near made tracks and plan your trip so that you can get back to your vehicle before dark, preferably with a thermos of hot coffee waiting for you. Remember that phone coverage is not universal! In my part of the world, personal locator beacons and a Mountain Radio service are more advanced safety options. Where coverage is available, personal location-finding apps like what3words can narrow your location down to a very small area.

I've found that the most risky habitats aren't the mountains or dense tracts of forest, but the coast. More than once I've been in danger of being caught out by swift-flowing incoming tides. It's very tempting to walk out over exposed sandflats at low tide to get near a feeding wader flock but, when the tide turns, often silently and very rapidly, you can be in serious trouble.

Normally, getting to the point where you are totally absorbed in your photographic project is a plus. But nature can be unforgiving and we need to be alert to unexpected dangers. You may not be squaring up to a polar bear, but there are occasions when a second pair of eyes (and ears) can be a lifesaver.

Sturdy footwear and a weather-proof coat are essential when tracking down the rock wren, which lives above the tree line all year round.

Camera: Canon EOS 7D. *Lens*: EF400mm f/5.6L USM. *Settings*: 400mm ƒ/5.6 1/400 sec ISO 400. © Paul Sorrell

Having a photo buddy
Two's company ...

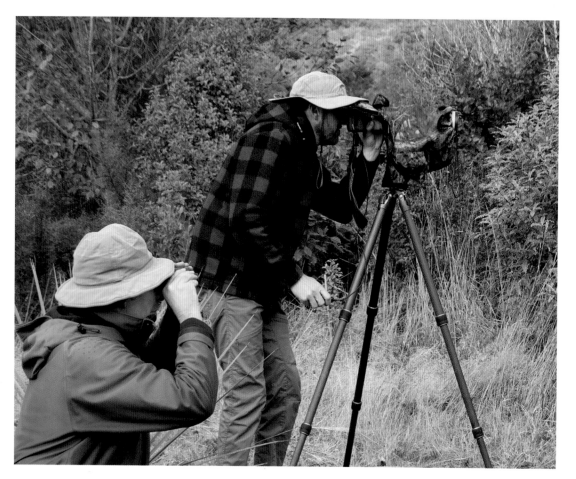

Wildlife photography can be a solitary — even lonely — pursuit. With the exception of a few occasions where you are exploring a specific area as part of an organized group, approaching shy animals across often rugged and unfamiliar terrain is an exercise that is best done on one's own. And such activity is not appreciated by everyone. Most people could hardly say to their best friend or partner, 'We're going to walk 100 metres into the woods, find a good spot and then stay put for the next three hours.'

However, if you are lucky enough to find one, a dedicated 'photo buddy' can be a real boon. Unless your life is so busy that you crave the occasional day of complete solitude in the wilderness, seeking out the company of another wildlife photographer can bring many benefits to your photography. First, you will have a

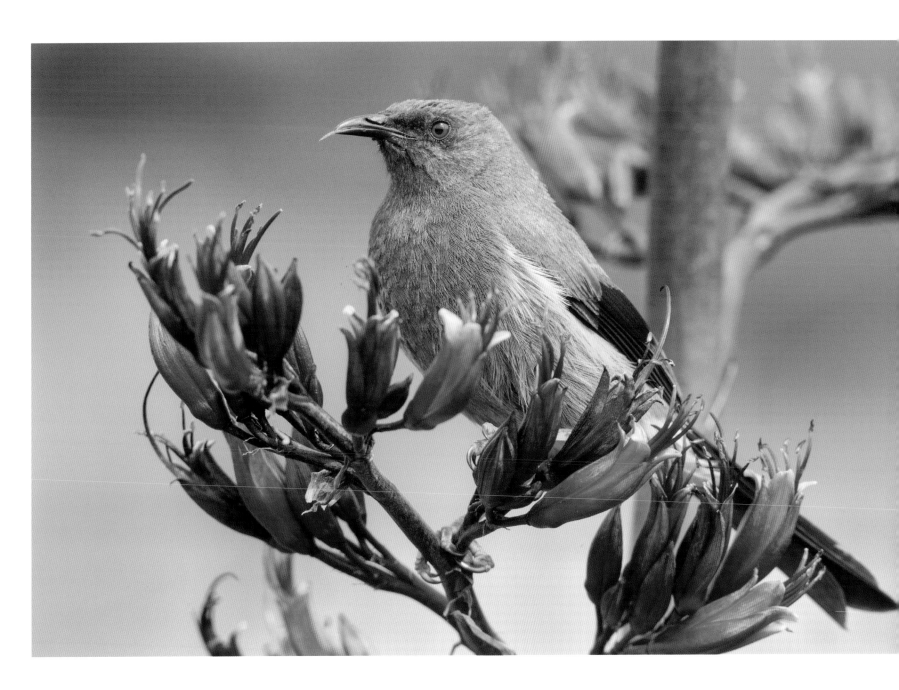

A bellbird feeds on flax flowers at a wildlife sanctuary near my home. Bellbirds are perhaps the most common birds in the reserve.

Camera: Canon EOS 7D. *Lens:* EF400mm f/5.6L USM.
Settings: 400mm ƒ/6.3 1/500 sec ISO 500. © Paul Sorrell

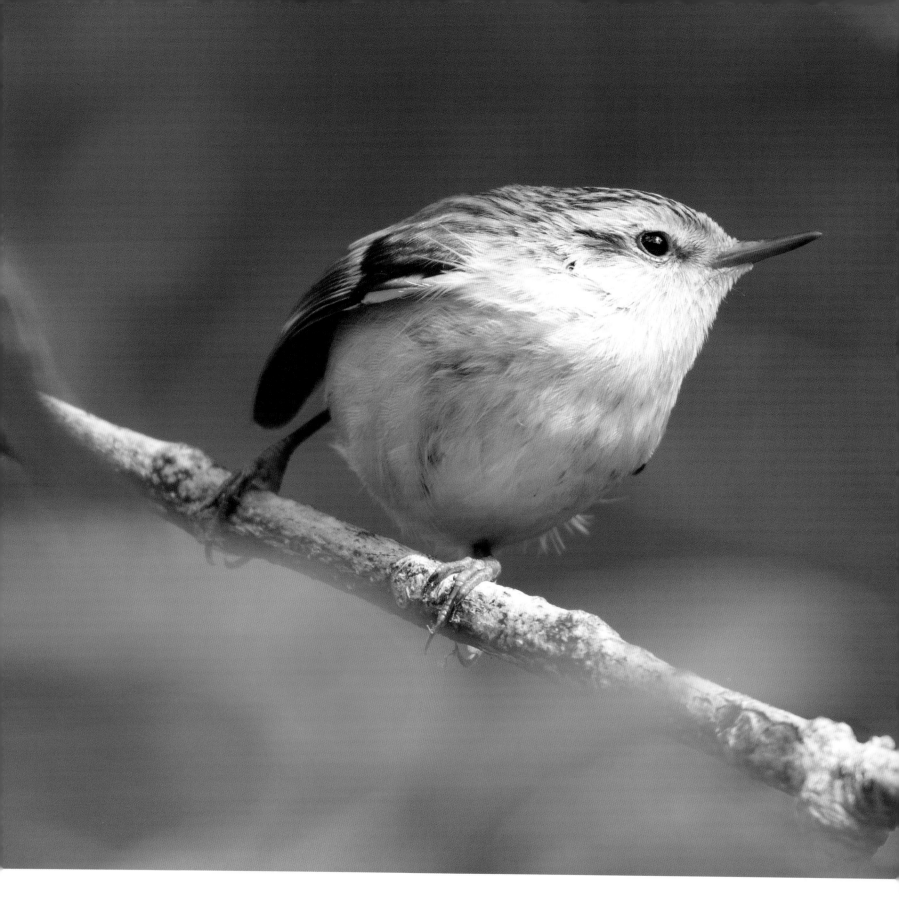

companion in arms in the field, someone to chat to in quieter moments, compare notes on gear, share the latest birding gossip, or simply enjoy a brew-up over lunch. Your partner will have ideas about where to go and how to do things that never occurred to you.

Learning to appreciate your companion's skills, and discovering the ways in which they complement yours, is an important part of the process. As happens to all of us as we age, I have lost the ability to hear very high-pitched sounds, such as the songs and calls of New Zealand's smallest — and very photogenic — bird, the native rifleman. But Neale can still hear their plaintive squeaking as we pass along a forest track or enter a clearing.

A good photo buddy can literally be your eyes and ears.

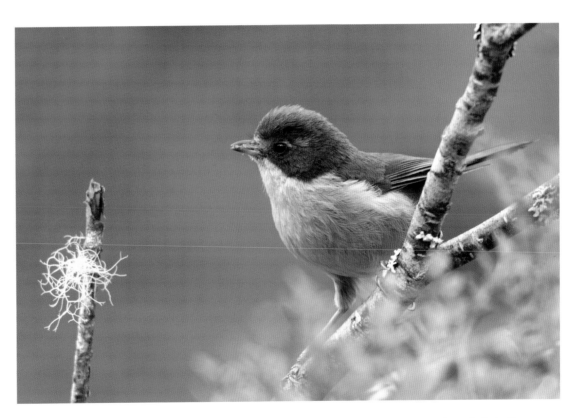

The elusive rifleman, New Zealand's smallest bird, is more often heard than seen — but only by young ears.

Camera: Canon EOS 7D. *Lens:* EF400mm f/5.6L USM. *Settings:* 400mm ƒ/5.6 1/400 sec ISO 640. © Paul Sorrell

The reclusive brown creeper has eluded all my attempts to photograph it at my local reserve; this image was captured during an expedition with my photo buddy to the Eglinton Valley, Fiordland.

Camera: Canon EOS 7D. *Lens:* EF400mm f/5.6L USM. *Settings:* 400mm ƒ/6.3 1/320 sec ISO 800. © Paul Sorrell

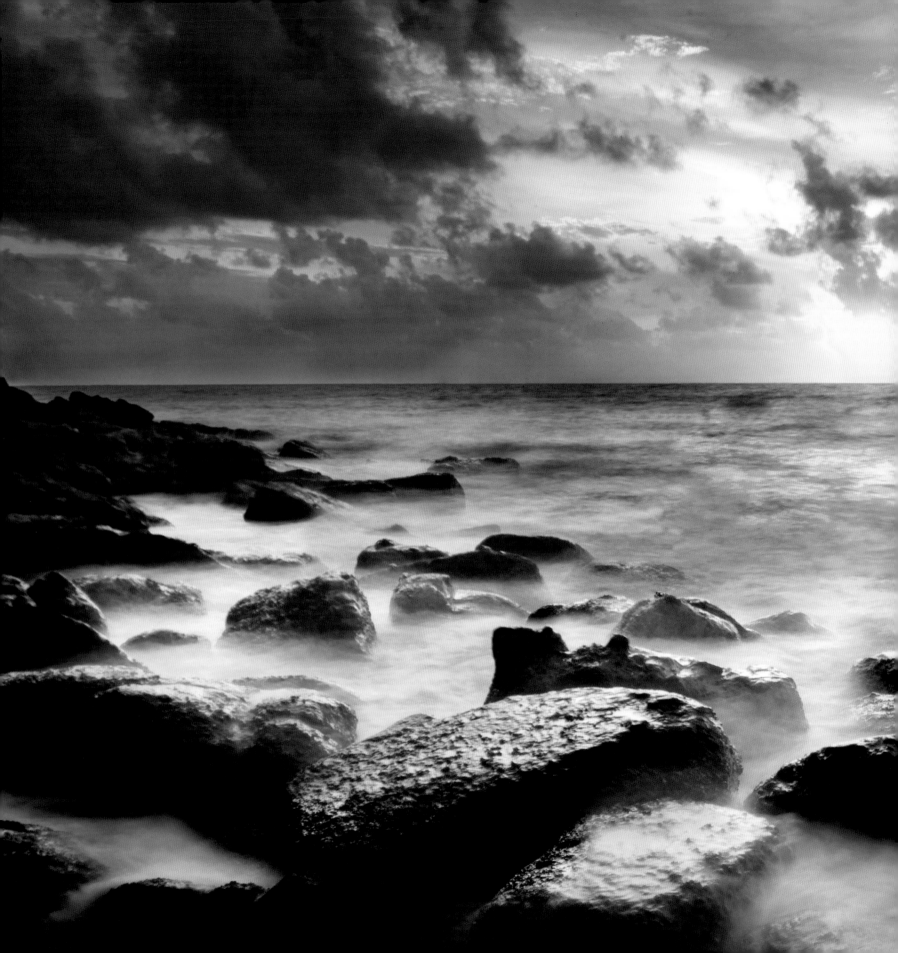

Making the shot

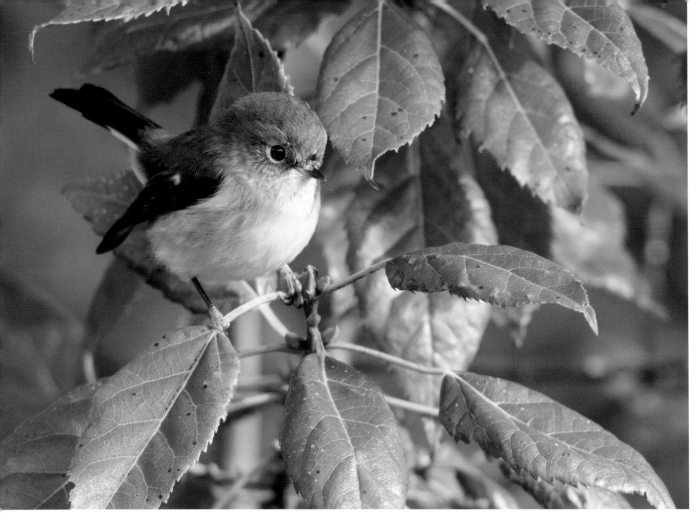

This female tomtit has been captured in soft morning light on a wineberry tree. Rather than obscuring the bird, the foliage acts as a frame around her and she is set on the left-hand horizontal 'third' (see pp. 70–73), further emphasizing her status as the subject of the image.

Camera: Canon EOS 7D. Lens: EF400mm f/5.6L USM. Settings: 400mm f/6.3 1/250 sec ISO 640.
© Paul Sorrell

Silhouettes can form striking images. This paradise shelduck stands out against the saturated reds of sunset on water.

Camera: Canon EOS 7D. Lens: EF400mm f/5.6L USM. Settings: 400mm f/5.6 1/2500 sec ISO 800.
© Paul Sorrell

HANDY HACK

If the sun is too bright, try shooting in the shade. However, I find that in shady conditions image tones can lack contrast and are often concentrated in the middle of the histogram. If you can, wait until the light improves.

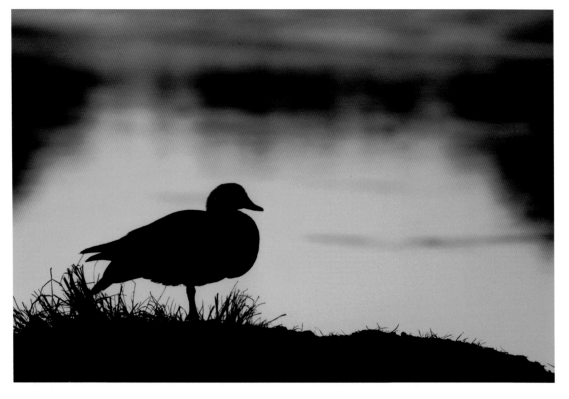

Playing with light
Exploiting nature's infinite palette

Light is the photographer's raw material. With each exposure you make on a digital camera, the image sensor is bombarded by photons that are captured by millions of cavities called photosites that convert the information received into electrical signals that are in turn processed by the camera. This process is not very different from what happens when light strikes your retina.

As soon as I became serious about photography, everywhere I went I started to notice the light, or, more precisely, its suitability for taking pictures. I constantly register light that is bright but subdued, delicately dappled or deliciously golden …

For outdoor photography, early morning and evening are the best times, when the light is warmer, glowing to red-gold at sunrise and sunset. For wildlife photographers, these are also the times when our quarry will be most active. The advantage of evening shooting, especially in an unfamiliar location, is that you can take the time to explore your surroundings and decide where you want to set up when the light is at its best.

My reflex position is to shoot with the sun coming over my shoulder, meaning that my subject will be evenly lit and there will be the obligatory catchlight in the eye. However, front lighting is not always possible, or even desirable, and it's good to experiment with different shooting positions with reference to the light. Backlighting through foliage can produced an attractive bokeh, while a raking side light can bring out the textures of plumage and fur.

Shooting into very low sun can allow you to capture the rim lighting that outlines the form of a bird or animal in a beautiful halo of warm light. And isolating a subject against an extensive lighter-coloured background at this time of day can result in striking silhouettes. The simpler these forms are, the more drama they will create. By underexposing by around one stop you will remove any detail from your subject and further saturate the brilliant colours of the golden hour.

At this time of day, getting a suitable exposure can be a problem if part of your image is brightly lit but the background, for example, is dark. Exposing my images on the evening I encountered a magnificent white heron (see p. 42) was a nightmare, as retaining detail in the bird meant that other parts of the image were underexposed. Constant reference to the histogram on my camera's LCD screen at least showed me where the problems lay.

Nevertheless, it's important to be alert to the quality of the light falling on the area behind your subject, as light and dark backgrounds can have dramatically different effects on the way your subject is presented. This is another area where experimentation is to be encouraged.

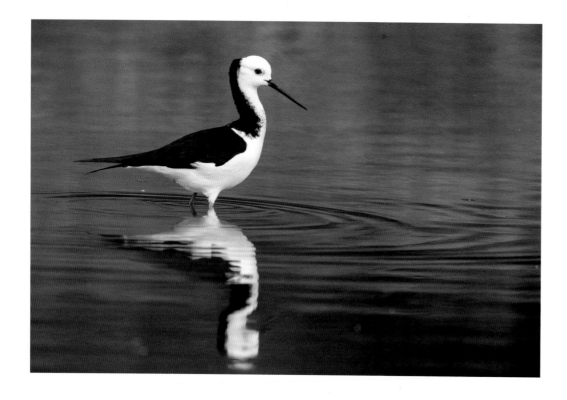

Finally, the play of light on water can give a special quality to wildlife photography. Getting as low to the waterline as possible means that you will capture part of the out-of-focus background as well as the water surface, allowing the subject to 'pop'. Capturing a pied stilt's reflection in still, shallow water can not only produce an appealing image, but because the bird's size is doubled in the frame you don't need to get so close. Shooting against the light can produce beautiful specular highlights in the foreground water. On the other hand, if the water is too bright or leaden in appearance, then look for areas of overhanging foliage or shadows produced by neighbouring hills — their reflections will produce areas of darker water that can often make for great backgrounds.

A pied stilt reflected in the foliage-shaded waters of a lagoon reserve.

Camera: Canon EOS 7D. *Lens:* EF400mm f/5.6L USM. *Settings:* 400mm ƒ/6.3 1/800 sec ISO 400. © Paul Sorrell

The sun filtering through the trees behind this New Zealand robin has produced an attractive bokeh, an effect complemented by the rich detail of its lichen-covered perch.

Camera: Canon EOS 7D. *Lens:* EF400mm f/5.6L USM. *Settings:* 400mm ƒ/6.3 1/160 sec ISO 400. © Paul Sorrell

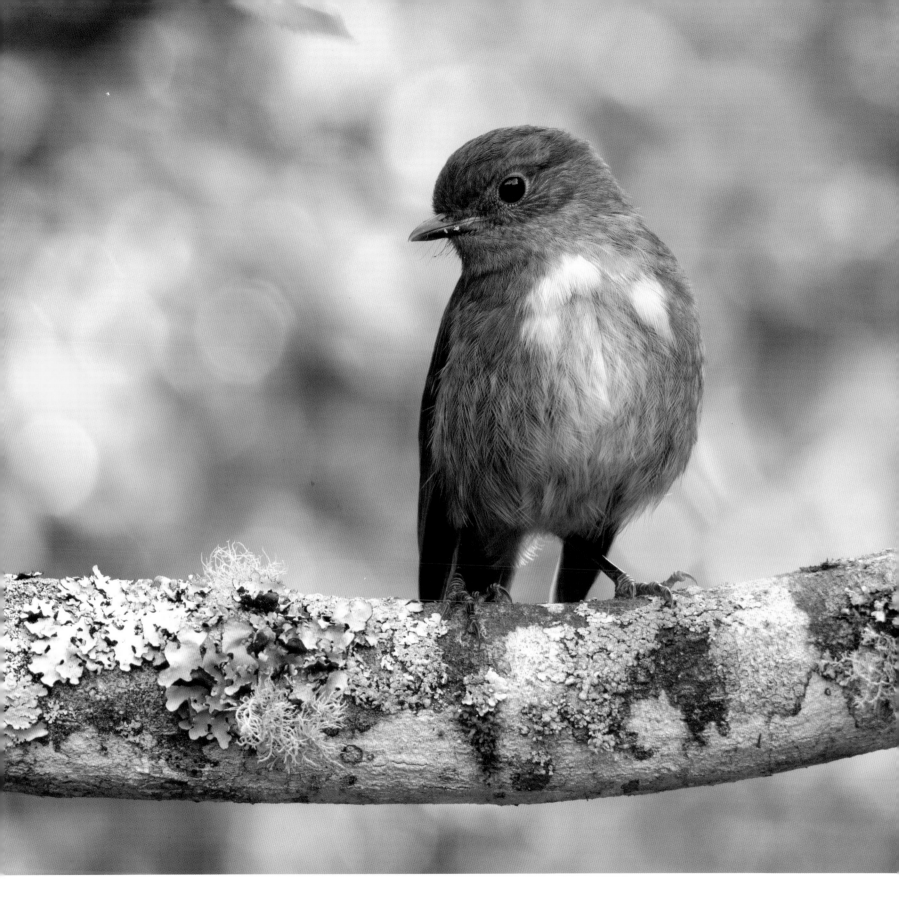

Putting things in perspective
Backgrounds, foregrounds and depth of field

Unlike the human eye, telephoto lenses can do something that wildlife photographers find particularly appealing — by locking onto a nearby subject, the background is thrown out of focus, directing our attention to the animal or bird in the frame.

Of course, results will vary depending on a range of technical factors: the distance between the photographer and the subject, and between the subject and the background; the size of the lens used; and the choice of aperture, which determines how much of the subject will be sharply rendered.

To put it another way, the closer you are to your bird, and the more distant the background, the more likely your subject will be framed by a diffuse creamy blur. The longer the lens and the wider the aperture, the greater the separation of the subject and the setting will be. Or, to use a technical term, the wider the aperture, the smaller the depth of field. For Canon users, the 600mm f/4 can't be beaten in terms of its ability to make the

subject 'pop' — despite being a very heavy and expensive piece of glass!

While telephoto lenses are able to isolate important elements in an image, they also foreshorten perspective, compressing subject, foreground and background and capturing only a small segment of the scene in front of you. The challenge for the photographer is to make this work creatively for you, selecting graphic elements that either make an aesthetically pleasing image or reflect something of the relationship between subject and setting.

Wide-angle lenses by contrast show much more of the scene, often in sharp focus front to back, and can make nearby objects look unnaturally large, even distorted. While these short lenses are an excellent choice for showing the subject's wider environment, the bird or animal will need to be close to the camera to be acceptably large in the frame. Birds like robins or young spotted shags, which are exceptionally tolerant or curious, make good wide-angle subjects. Alternatively,

you can use a remote shooting technique such as setting up your camera close to a nest.

More on backgrounds and foregrounds

There are many ways of creating the kind of setting you want. Sometimes, just stepping a few feet to the right or left will increase the distance between subject and background or remove distractions like intrusive foliage or twigs. Backgrounds lit by low sun can be very attractive, as can those in deep shadow — you can turn these areas black by underexposing a stop or so.

And don't neglect foregrounds. They often contain framing features than can add depth to your image as well as drawing attention to the subject. By lying down to photograph a small bird on the ground, you will not only achieve a greater sense of intimacy, but foreground elements can be attractively blurred — as in my photograph of a blackbird fledgling, where a carpet of out-of-focus daisies leads the eye to the main subject.

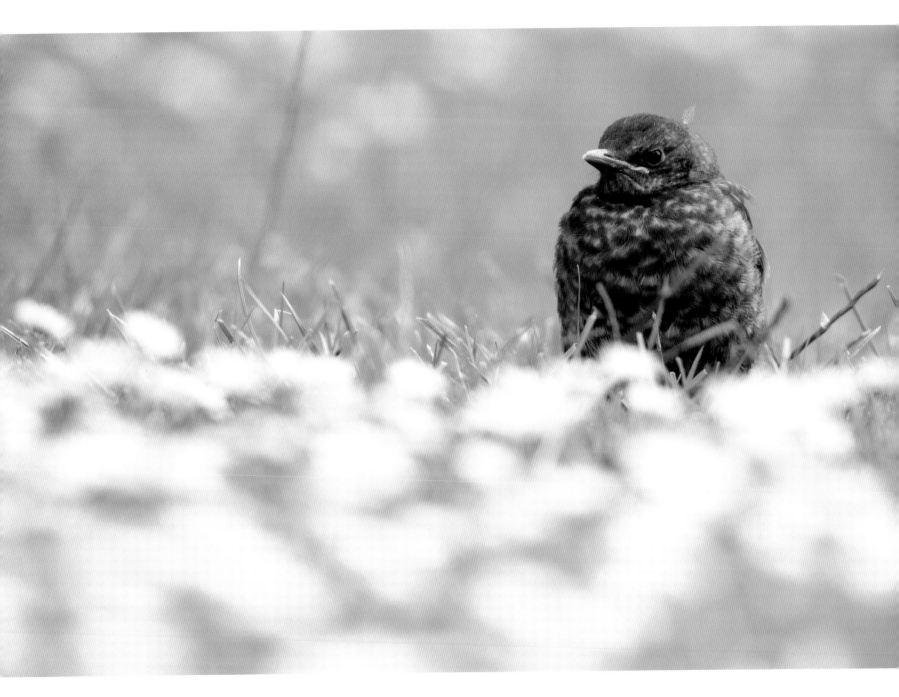

A springtime scene in my local botanic garden,
showing effective use of foreground elements.

Camera: Canon EOS 50D. *Lens:* EF400mm f/5.6L USM.
Settings: 400mm ƒ/5.6 1/800 sec ISO 400. © Paul Sorrell

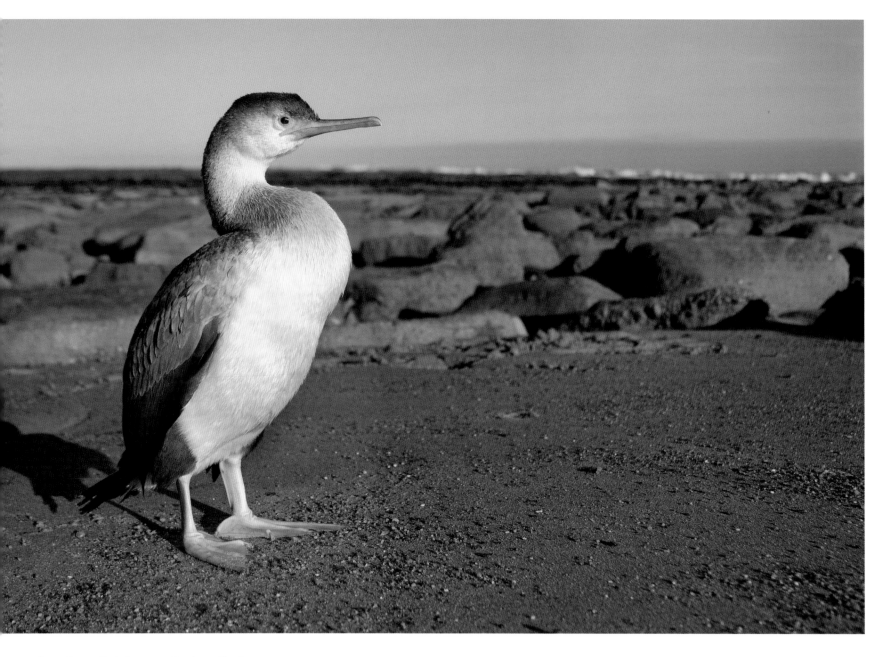

Juvenile spotted shags are fearless; I had to back away to fit this bird even in my wide-angle (28–135mm) lens.

Camera: Canon EOS 50D. *Lens:* EF28-135mm f/3.5-5.6 IS USM. *Settings:* 400mm ƒ/5.6 1/3200 sec ISO 400. © Paul Sorrell

Where the background is distant, a telephoto lens can create a uniform blur that makes the subject — here a juvenile little owl — 'pop'. *Shutterstock* © Wim Hoek

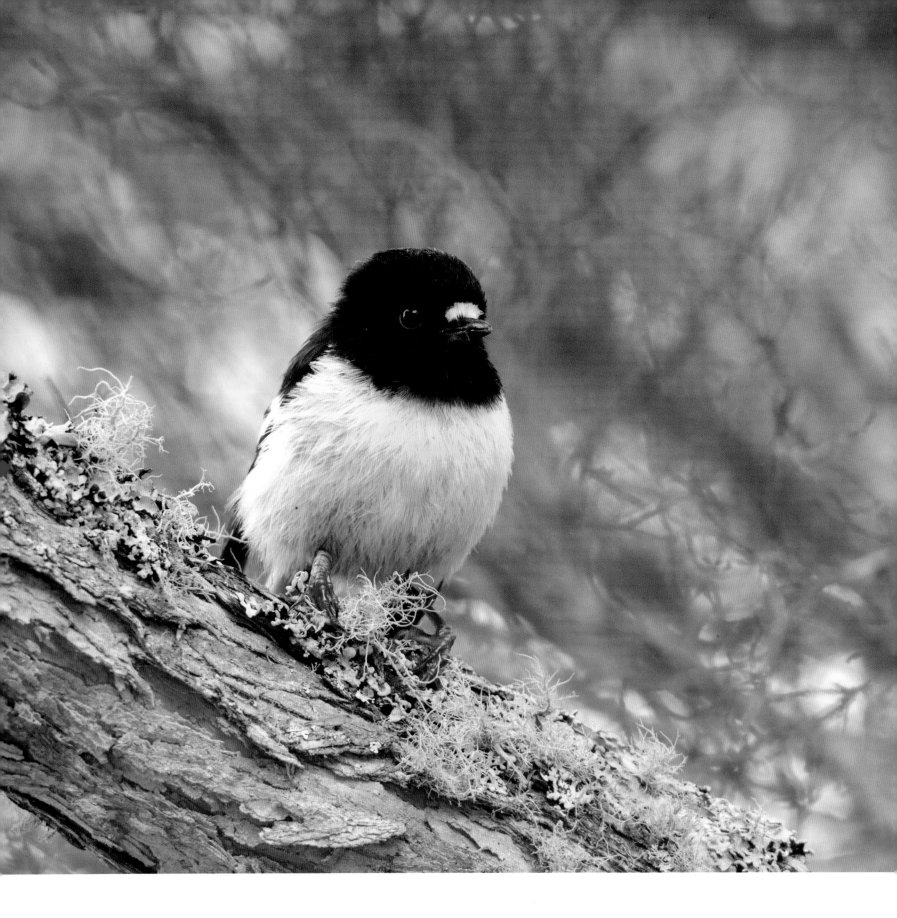

Close up or far away?
Choosing what to include in the image

The sun-dappled forest canopy makes a pleasing backdrop for this male tomtit sitting on a lichen-covered branch.

Camera: Canon EOS 7D. *Lens*: EF400mm f/5.6L USM. *Settings*: 400mm ƒ/6.3 1/200 sec ISO 800. © Paul Sorrell

When I started out, getting close to birds was a novelty. With a 400mm lens attached to my crop-sensor camera I could make small birds appear quite large in the frame, and by adding an extension tube I could approach as close as 2 metres (6ft).

Taking close-up shots allows you to achieve a sense of intimacy with your subject, displaying (in the case of birds) details of plumage that would otherwise be lost. Sometimes the decision is made for you — for example, when a large bird lands right beside you or you are photographing a species that is especially confiding. New Zealand dotterels — at least the southern race with which I am familiar — are both inquisitive and fearless and will often wander right up to an observer.

However, while frame-filling portraits can deliver a lot of information about a bird, they say little about its environment. The most effective wildlife images tell the viewer a story, even if it is no more than where the subject lives or how it interacts with its habitat.

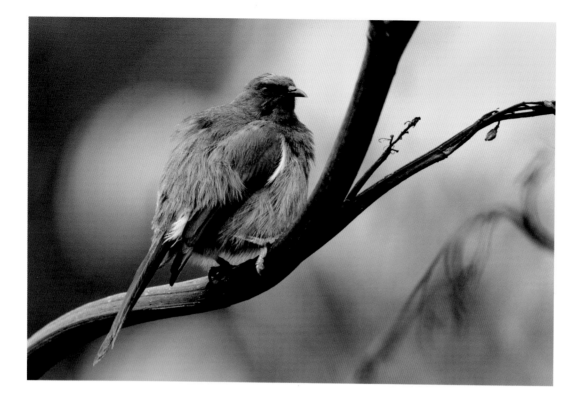

Environmental portraits fall into two broad categories. In the first kind, the subject is shown in its immediate setting, so it will still be fairly large in the frame. Here the bird's posture and attitude will be foregrounded, with the setting acting more as an aesthetically pleasing frame than offering information about habitat and behaviour. With this kind of shot, it is important to avoid losing the bird amid messy foliage or including distracting or out-of-focus elements like light-coloured twigs or grasses.

By contrast, showing the subject in its wider setting can tell us a lot about its place in the environment and even the role it plays in a particular ecosystem. With careful attention to composition, it is possible here, too, to create an artistically pleasing image. A tiny bird (such as a brightly coloured kingfisher or hummingbird) that is well defined against a background that complements rather than overwhelms the subject can make a very effective image.

I photographed this bellbird in a grove of flax plants where many birds (mainly bellbirds and tūī) were feasting on nectar. This bird was carefully guarding its chosen plant, occasionally fluffing up its feathers to warn rivals away. By choosing a setting where birds were intent on feeding, and including as much information as I could about their activity, I was able to produce an image with a story to tell.

Camera: Canon EOS 7D. *Lens:* EF400mm f/5.6L USM. *Settings:* 400mm ƒ/6.3 1/640 sec ISO 400. © Paul Sorrell

I photographed this grey teal, a small native duck, while waiting for crested grebes to swim up this creek flowing into an inland lake. The grebes never showed up, but my patience paid off with this quiet portrait of an attractive waterfowl in its habitat.

Camera: Canon EOS 7D. *Lens:* EF400mm f/5.6L USM. *Settings:* 400mm ƒ/5.6 1/400 sec ISO 400. © Paul Sorrell

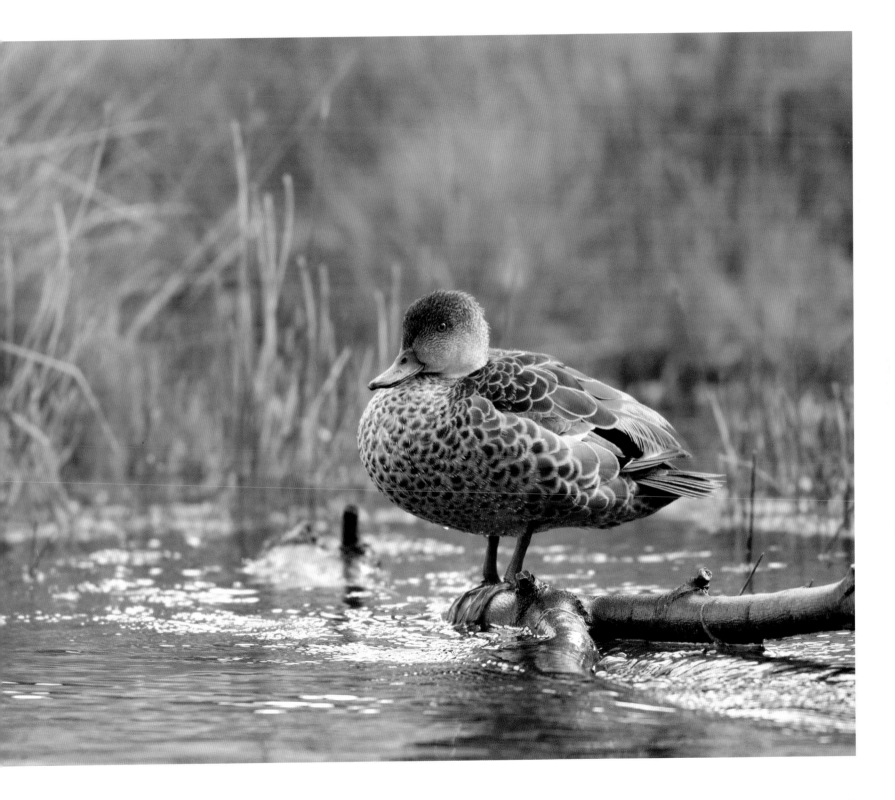

Composition 1
The rule of thirds

Composition refers to the way in which the elements in a photograph are arranged within the frame. The choices you make, consciously or not, will determine what is given prominence in your image — whatever *does* stand out will be treated as your main subject by those seeing the image.

Very different compositions can be achieved both at the time you take the photograph — by moving the camera to frame your subject in different positions and from different angles — and by cropping the image during post-processing. Whether the bird is at the top or bottom of the frame, to the left or right, or bang in the middle, this will impact the viewer in different ways and give a distinctive 'feel' to the shot.

One well-tested approach to effective composition is the rule of thirds. This involves placing the subject or a key part of it (such as the eye) on a line in an imaginary grid that divides the photo frame into nine equal portions. The points where the lines intersect are particularly powerful

LESS IS MORE

I had seen and heard a fernbird calling from the top of a coprosma bush at my local wildlife sanctuary and was determined to capture the action against a very simple backdrop. One morning everything came together, and I got several shots I was pleased with. I manoeuvred myself so that the background was a distant hillside, rather than a bright sky, and the scene was free of other distracting elements. Choosing a fast shutter speed (1/1000 second), I took a rapid succession of shots so that some at least would show the bird with its beak wide open, pouring out its staccato song.

New Zealand fernbird.

Camera: Canon EOS 7D. *Lens:* EF400mm f/5.6L USM.
Settings: 400mm ƒ/5.6 1/1000 sec ISO 800. © Paul Sorrell

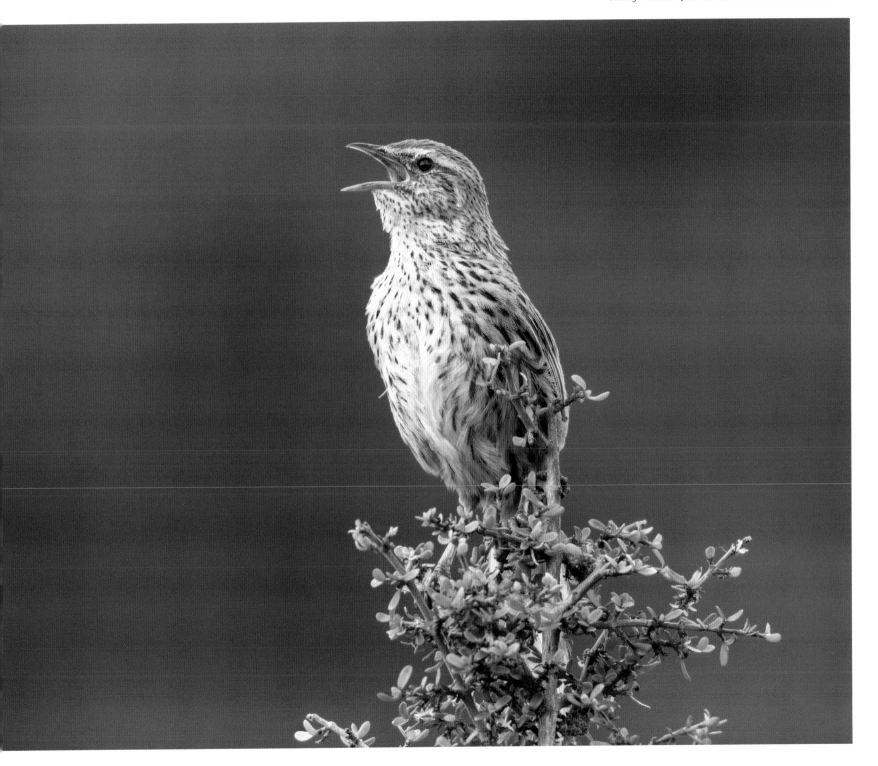

The effect of complementary colours, combined with the rule of thirds, makes this grey warbler an eye-catching subject.

Camera: Canon EOS 7D. *Lens*: EF400mm f/5.6L USM. *Settings*: 400mm ƒ/5.6 1/400 sec ISO 400. © Paul Sorrell

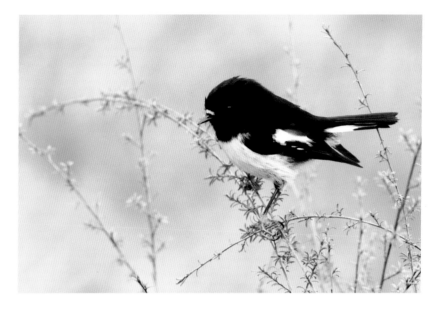

A male South Island tomtit.

Camera: Canon EOS 7D. *Lens*: EF400mm f/5.6L USM. *Settings*: 400mm ƒ/6.3 1/500 sec ISO 640. © Paul Sorrell

and immediately draw the eye. This schema has some similarities with the golden ratio or golden section, which some claim was used as a compositional tool by artists and architects for centuries before the advent of photography.

In my practice, I've internalized the rule of thirds to the extent that I nearly always frame the subject in this way before pressing the shutter. It's one of those actions that has become so habitual that it's almost unconscious.

Of course, using the rule of thirds is not always appropriate. Although budding photographers are routinely warned against plonking the subject in the middle of the picture, there are times when this rule (like all rules) should be broken. For example, when your subject exhibits strong elements of symmetry, perhaps created or enhanced by reflection in water.

The crop tool in Photoshop Elements allows you to overlay a grid on your image to apply the rule of thirds.

Composition 2
Framing up

As a basic compositional tool, the rule of thirds allows you the freedom to think about where you want to place your subject for maximum impact. The concept of negative space is useful here. For example, by choosing a plain background and placing your subject — or its head or eye, if it's a close-up — to one side of the frame, you will allow plenty of space for it to look or move into. You are letting the bird 'breathe'. A bird with its beak jammed up against the photo border is going to look terrible — unless, of course, you are seeking a dramatic effect!

Alongside the rule of thirds, one sometimes hears of the 'rule of odds' — the suggestion that you should avoid even numbers of subjects in your photographs. So, if there are two birds in the image, our eye tends to flit from one to the other. Which is the subject? There are times when this isn't a problem — for example, when the two birds are interacting in some way or are close enough to form a single subject, as in the pair of

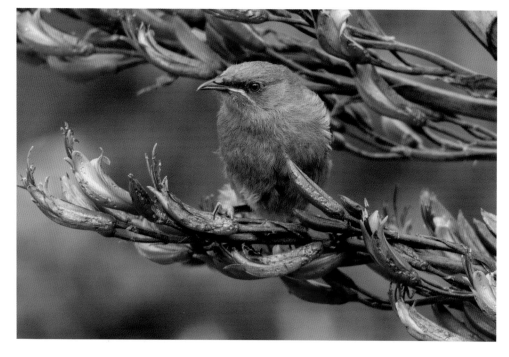

Flowering flax stems form an effective frame for a juvenile bellbird.

Camera: Canon EOS 7D. *Lens:* EF400mm f/5.6L USM. *Settings:* 400mm ƒ/5.6 1/500 sec ISO 800. © Paul Sorrell

The use of a strong diagonal or vertical feature can enhance your subject — here a bellbird.

Camera: Canon EOS 7D. *Lens:* EF400mm f/5.6L USM. *Settings:* 400mm ƒ/5.6 1/800 sec ISO 800. © Paul Sorrell

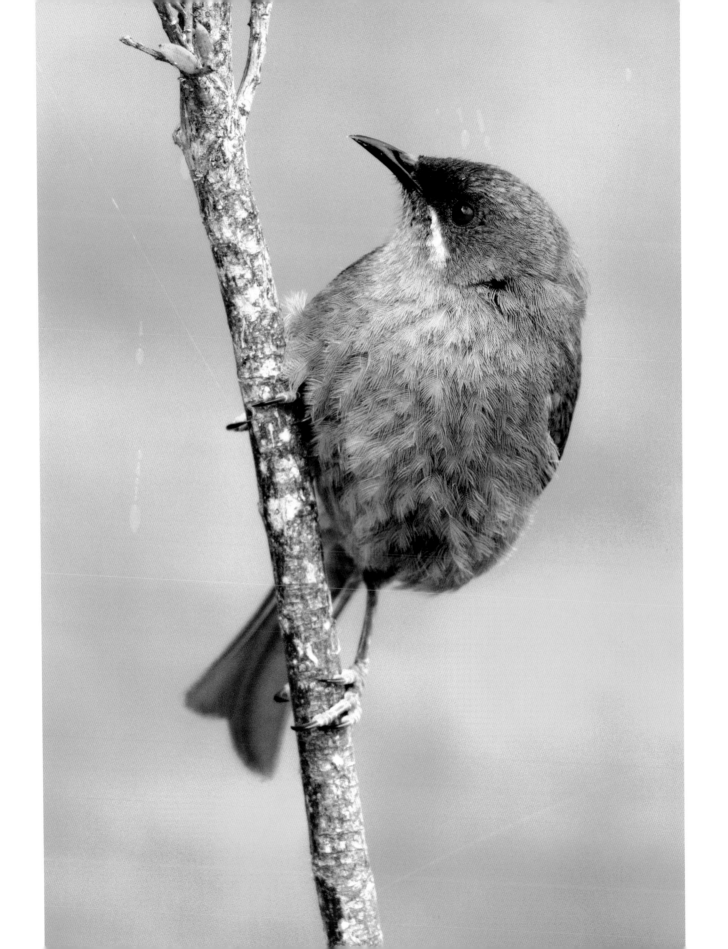

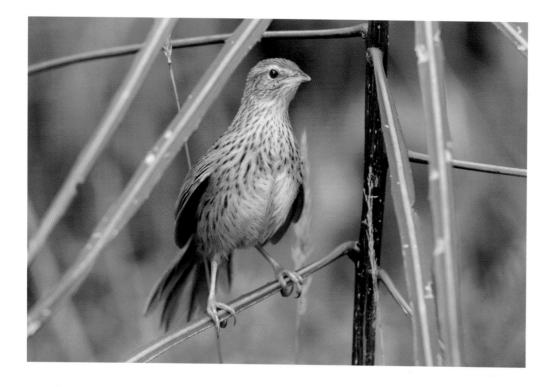

This fernbird is nicely framed by slanting lancewood leaves.

Camera: Canon EOS 7D. *Lens*: EF400mm f/5.6L USM. *Settings*: 400mm ƒ/6.3 1/640 sec ISO 800. © Paul Sorrell

While it's important to avoid competing subjects in an image, in graphic terms this pair of variable oystercatchers forms a single unit.

Camera: Canon EOS 7D. *Lens*: EF400mm f/5.6L USM. *Settings*: 400mm ƒ/5.6 1/500 sec ISO 400. © Paul Sorrell

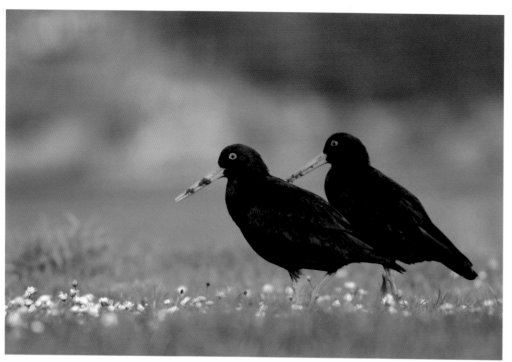

variable oystercatchers below. The rule of odds also doesn't apply where a second, out-of-focus, bird appears as a twin or 'shadow' of the main subject (see p. vi).

One simple but striking way of composing an image is to make a feature of strong vertical or horizontal elements or use lead-in lines to emphasize your subject. Diagonal lines are especially effective in bird photography. The simplest way of highlighting them is to shoot your subject on a sloping branch or twig that stretches across the frame.

Another effective compositional device is the frame-within-the-frame. By including a border of foliage, for example, or using a built feature like a window or arch, you can draw added attention to your subject, and engage in some creative aesthetic effects.

Among the things to avoid when composing your shot is having your subject too small in the

TOP TIP While it's important to leave plenty of space for your subject to look into, I generally leave as little space as possible *behind* the subject. While this is often difficult to achieve in-camera — you run the risk of amputating some tail feathers — it is easy to do when you crop the image.

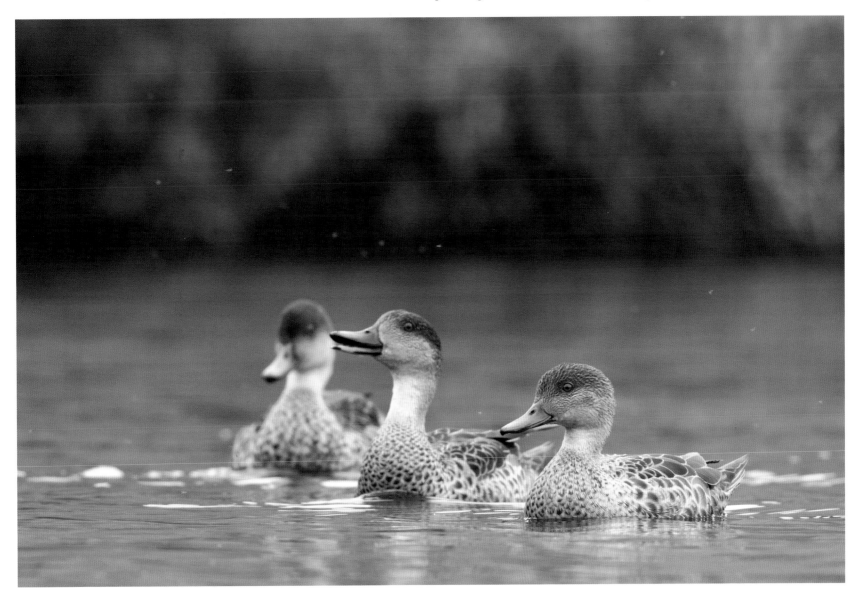

frame. But again, even a tiny main star will shine if it stands out from its surroundings through its colouring and placement (such as a kingfisher on a riverside perch), of if the tiny subject is balanced by a complementary element — perhaps a landscape feature such as a large boulder which is visually interesting in itself.

This trio of grey teal illustrates a number of compositional techniques. While each duck strikes a different pose, the lack of separation between them means they can be seen as a single unit in graphic terms. The bird closest to the camera is sharp, while the others progressively fall out of focus, leading the eye from right to left. Finally, the out-of-focus background does not distract from the main subject.

Camera: Canon EOS 7D. *Lens:* EF400mm f/5.6L USM. *Settings:* 400mm ƒ/8 1/250 sec ISO 400. © Paul Sorrell

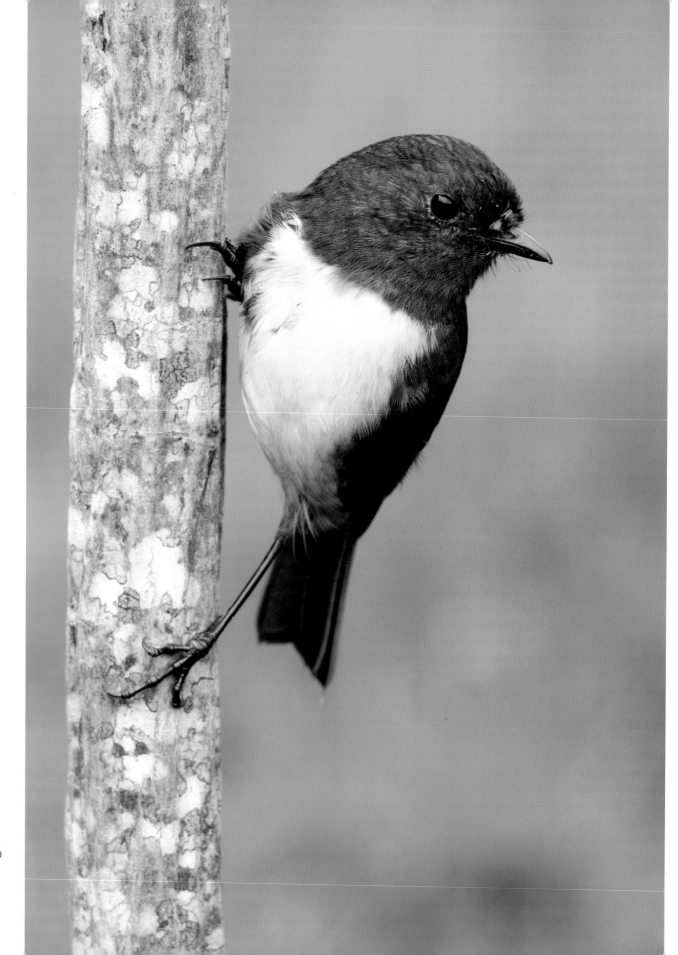

A South Island robin poses on a lancewood sapling. The vertical format emphasizes the shape of the tree with its attractive textures and tones.

Camera: Canon EOS 7D. *Lens:* EF400mm f/5.6L USM. *Settings:* 400mm ƒ/6.3 1/200 sec ISO 800. © Paul Sorrell

Composition 3
Cropping and formats

For me, cropping my images at the processing stage is a key aspect of composition and an essential part of my workflow.

The way you crop your photographs is important — what you leave out can be as revealing as what you include. Different crops will not only change the 'look' of your image, but they will affect the viewer's response, even to the point of eliciting quite different emotions.

Photo-editing software like Photoshop Elements allows you to choose various cropping formats, including 'photo ratio' and square (the popular Instagram format). Another option is panoramic, where a series of shots can be digitally stitched together to produce a long, seamless vista. I almost always choose the standard 3:2 photo ratio, which allows you to readily implement the rule of thirds and is the best format for submitting to publications and competitions.

As my APS-C camera has a built-in crop factor, I mostly crop very lightly — between 5 and 10 per cent — usually with the aim of aligning the composition with the rule of thirds. It's always a good practice to try to frame up the image as you want it to look in-camera and not do much more than tweaking at the processing stage.

Sometimes, of course, especially if you lack the leisure to consider your options, you'll want to leave more space around the image when you take the shot. The crop tool is especially useful when you need to level up your image or fix wonky horizons. At least half the images I take of waterbirds when lying (often awkwardly and uncomfortably) at the edge of a lake or lagoon need adjusting in this way.

A further aspect of composition, allied to cropping, is the question of landscape (horizontal) versus portrait (vertical) format. The nature of the subject will usually determine which format is most effective. Any subject with strong vertical elements — a heron stretching out its neck or a robin posing on an upright sapling — is an obvious candidate for portrait treatment. Nature photographers often neglect portrait mode, but vertical shots can be graphically strong. And when the action is unfolding in front of you, it makes sense to shoot in both modes. This is especially important if you are considering publishing your images.

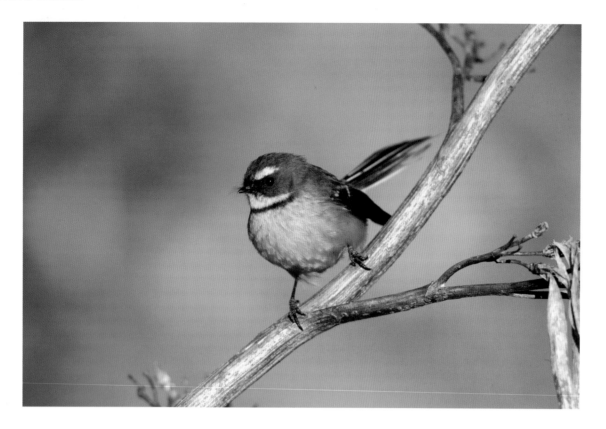

These images show the progress of a single photograph (a pied fantail on a flax stem) from opening in Raw editing software (where some initial processing is done) through further manipulation (including cropping) in Photoshop Elements to produce the final image.

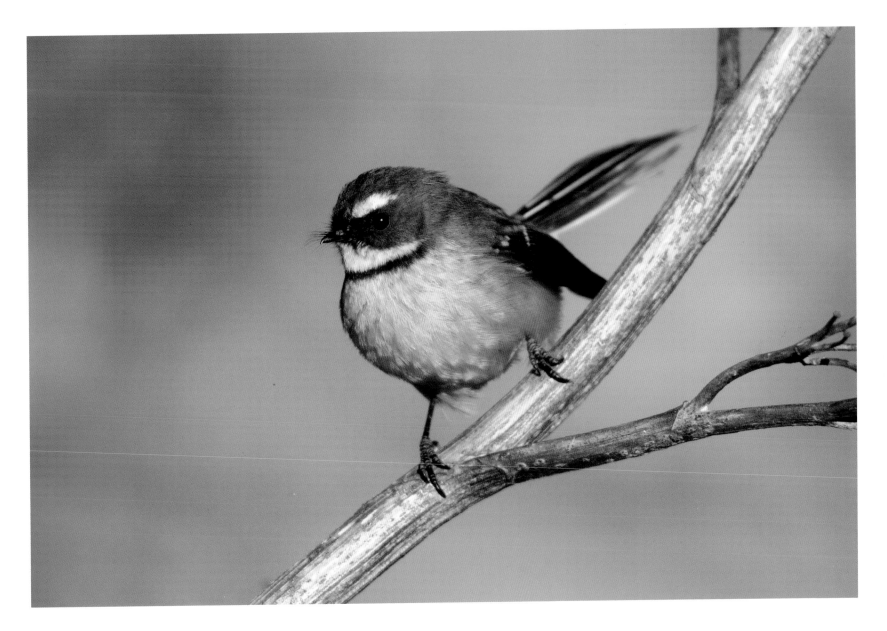

HANDY HACK

Your editing software may well offer you a range of suggested crops for your image. Being computer-generated, these are mostly very strange (cutting off your subject's tail, for example) and to be avoided, but occasionally they can be helpful.

Colour and texture
Adding extra impact

In the digital age, there's no escape from colour. Photographers have become familiar with names like Spyder and Colormunki as we calibrate our monitors to ensure that the colours in our images are accurate and reproduce uniformly across all our devices. We can set our colour space in-camera, determining the gamut of colours that will be available when uploading images to our computers and printers. Depending on the white balance setting we choose, we can warm our colours up or cool them down. And if a wayward colour cast should remain after all this, we can whisk it away in Photoshop.

It is with a feeling of relief that I turn to a more traditional way of understanding colour — the colour wheel, which represents colour hues and their relationships. Although it is usually difficult to choose colours when photographing animals in the wild, certain combinations can enhance an image. While adjacent colours on the wheel are known as 'analogous', and work well together,

when matched with their opposites on the wheel, the three primary colours — red, yellow and blue — are especially potent. These 'complementary' pairs are red and green, yellow and purple, and blue and orange.

Red and green are commonly found together in nature. In the image reproduced on p. 85, the male redpoll's brilliant red breeding plumage shows to advantage against the fresh grass of spring as it forages for seeds. Even a tiny splash of red can have a striking effect against a green background, as my image of a grey warbler sitting on a coprosma bush in my local botanic garden shows (p. 72).

The flipside of colour is black and white. Removing colour from an image reduces it to its essential elements, emphasizing graphic qualities such as form, structure and texture. Without colour, the emphasis falls on tone and tonal variation. A good range of tones from pure black to pure white can make for a satisfying image. Black and white also works well with silhouettes,

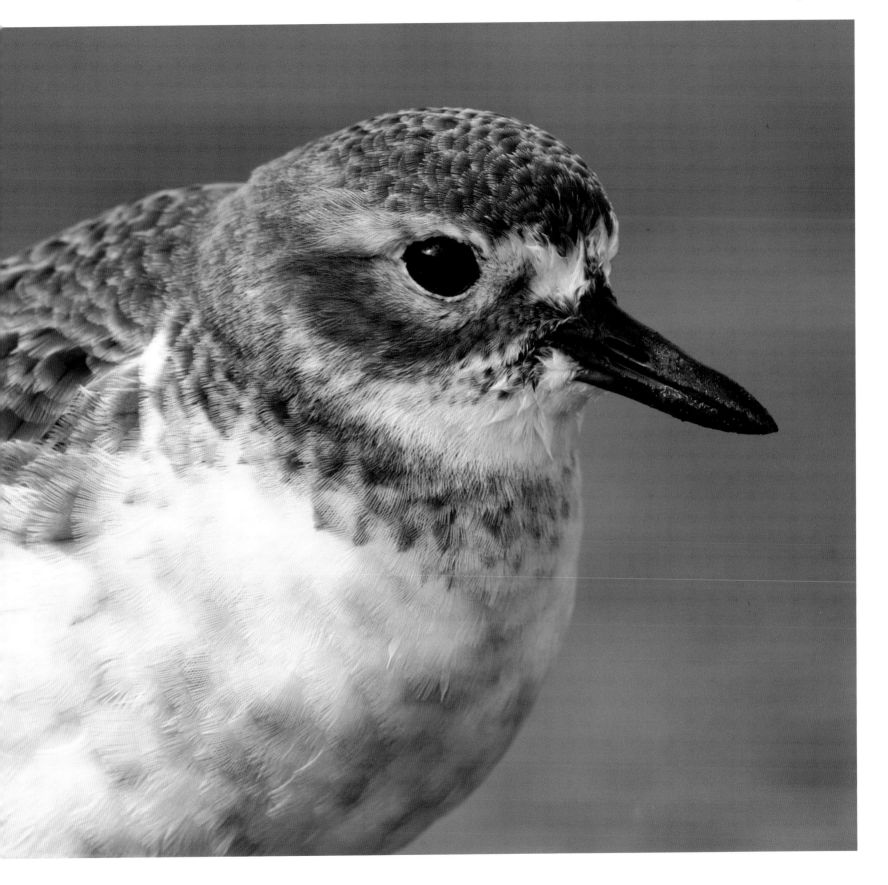

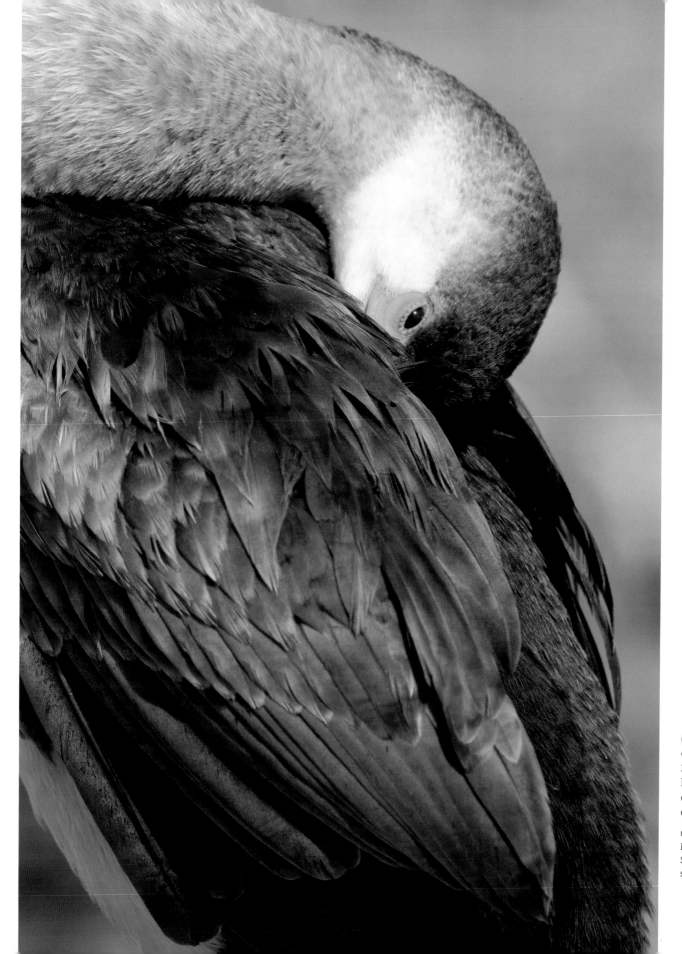

My decision to reveal
only part of the bird
(a spotted shag)
allowed me to show off
feather detail, create
interesting forms and
emphasize colour.

Camera: Canon EOS 50D.
Lens: EF400mm f/5.6L USM.
Settings: 400mm ƒ/8 1/1000
sec ISO 200. © Paul Sorrell

(Previous page) This
close-up of a New
Zealand dotterel
highlights the subtle
colours and textures
of its plumage.

Camera: Canon EOS 20D.
Lens: EF400mm f/5.6L USM.
Settings: 400mm ƒ/8 1/640
sec ISO 400. © Paul Sorrell

The choice of complementary colours — here the red crown and breast of a redpoll against green grass — can make for an arresting image.

Camera: Canon EOS 50D.
Lens: EF400mm f/5.6L USM.
Settings: 400mm f/5.6 1/250 sec ISO 400.
© Paul Sorrell

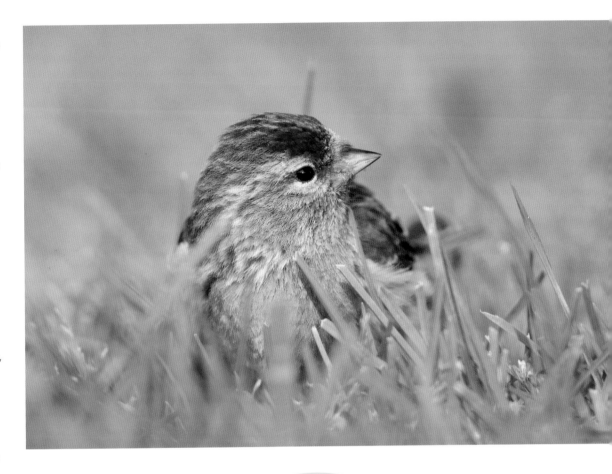

where strong dark forms are isolated against a light background.

Sometimes an image that is almost monochrome, but retains a hint of colour, can be very effective. My godwit image (p. 50) is a case in point. By choosing 'cloudy' white balance in post-production (after all, it was a cloudy day), the photograph was suffused with an attractive sepia toning except for the bird's long pink bill, an element that subtly asserts itself in the finished image.

Black-and-white photography is also a good medium for emphasizing texture. This is especially evident in close-ups. In birds, feather detail shows up well in close-up portraits, as in my head-and-shoulders shot of a New Zealand dotterel or a very relaxed spotted shag. In addition to showing plumage detail, the shag image shows how the choice of angle and graphic elements can produce an abstract feel, enhanced by the selective use of colour — here the patch of yellow skin around the bird's eye.

The colour wheel. By choosing either neighbouring or opposite colours on the wheel, photographers can add impact to their images.

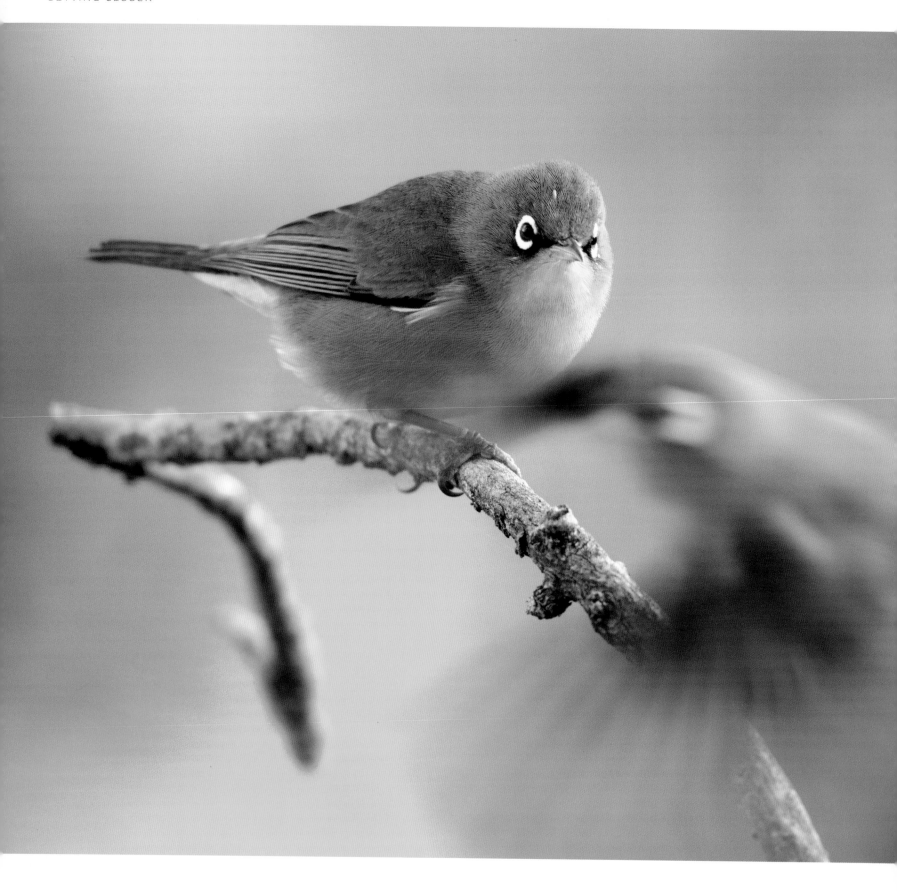

Birds in motion
Capturing the action

Learning to capture your subject in motion will add a whole new level of interest and excitement to your photography. The action can range from a seagull bathing vigorously, framed by a halo of water droplets, to a great bustard striding through grassland, to a magnificent eagle soaring high against a backdrop of snow-covered mountains.

Flight photography is perhaps the most challenging aspect of wildlife work. You can improve your chances of success by opting for good light and seeking out places where particular behaviour is likely to be found. For example, if you have a backyard feeding station, after a while you will be able to predict your visitors' flight paths to the food, or the spots where they are likely to engage in aerial squabbling. It's a good idea to hone your skills by practising on common species like gulls or slow-flying herons and egrets. With flight photography, it's practice that makes perfect.

Observation will also help you pick up cues from animal behaviour. Many birds will stretch their wings or defecate just before taking off, and a begging fledgling that becomes especially animated is no doubt about to be visited by a parent with a beakful of insects, providing the opportunity for action-packed feeding shots.

Becoming proficient in this area means mastering a range of skills, both practical and technical.

First, make sure your camera is set to continuous autofocus, with maximum burst rate. Acquiring and maintaining focus on the most important part of your subject — the head and eye — is the most difficult part of the whole process. To achieve this goal, you can choose either a single focus point — the centre point is the most sensitive — or a group of points. Experiment to find what works best for you. To freeze your subject in the air, choose a shutter speed of at least 1/1000 second. (Of course, if you want to create a background blur, or capture wing

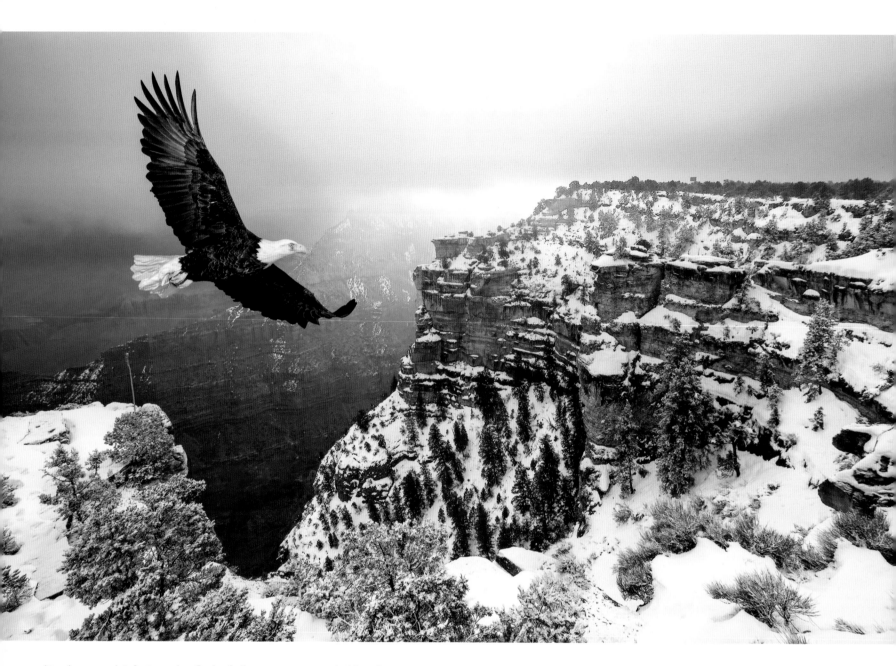

(Previous page) A fast-moving flock of silvereyes in my backyard gave me the chance to capture stillness versus motion in the one frame.

Camera: Canon EOS 7D. *Lens:* EF400mm f/5.6L USM. *Settings:* 400mm ƒ/5.6 1/160 sec ISO 800. © Paul Sorrell

A bald eagle soars over a snow-capped Grand Canyon. *Shutterstock* © Steve Collender

movement, you will want a slower speed.) An aperture of around f/8 will improve your chances of capturing sharp detail where it counts.

In addition to these settings, the way you use your lens is important. While a heavy lens (500 or 600mm) is best mounted on a tripod equipped with a highly manoeuvrable gimbal head, a lighter 300 or 400mm lens can be hand-held. (My medium-sized Canon 400mm f/5.6 is an ideal flight lens.) With your feet astride and elbows tucked into your sides, track your subject with a smooth panning motion. You'll find it easier if you point your feet facing where you plan to finish panning, rotating from the waist.

Keep your focus slightly ahead of the bird if it's flying across you. If the bird is approaching from the distance, try to lock on early so that you have a better chance of tracking it as it comes towards you.

Good luck, and don't ever give up!

TOP TIP Getting the correct exposure is always challenging when following a flying subject that may be silhouetted against a bright sky one moment and passing in front of dark hills or cliffs the next. With your shooting mode set to manual, take a meter reading off a neutral feature like grass or rocks to ensure a consistent exposure.

If your subject flies too close, and the wings and tail are clipped, don't despair — you can get dramatic results by creative cropping.

To capture small birds that are flying towards you too fast for the autofocus to lock on, focus manually at a point you expect them to pass through and fire off a burst — at least one frame is likely to be sharp!

Flying feathers and water drops always add dynamism to a photograph of a bird bathing. This is a red-billed gull.

Camera: Canon EOS 7D. *Lens*: EF400mm f/5.6L USM. *Settings*: 400mm ƒ/6.3 1/1600 sec ISO 200. © Paul Sorrell

The eyes have it
Communicating intimacy

Creating a sense of intimacy with your subject is paramount in wildlife photography.

Just as we unconsciously make eye contact with those we are speaking to, as a way of connecting with the other person, so looking a bird or animal directly in the eye can have a powerful impact. It can signal all kinds of relationships — communicating acceptance, trust, pleading, even fear. It can produce answering emotions in the beholder — think how you would feel meeting the gaze of a grizzly bear just 20 metres away.

When photographing birds, making eye contact may just be a question of waiting until your subject turns its head towards you. Perhaps surprisingly, a full frontal gaze is generally to be avoided — such a pose can look disconcerting, even comic. I've found that the most satisfying angle is the classic three-quarters profile, with the head turned slightly towards the observer. You don't want the bird turning away, let alone with its back to you — unless this pose is sought for special effect.

THEY GOT RHYTHM ...

I photographed this group of pied oystercatchers on a local beach while crawling over the sand in pursuit of a skittish flock of bar-tailed godwits. When the godwits suddenly flew off, I was in a good position to capture this relaxed group of roosting waders. Looking at the image, we are drawn to the prominent red eye of the foremost bird, then to the other oystercatcher eyes, in varying degrees of focus. These repeated elements give a sense of rhythm to the composition, a quality accentuated by the birds' legs.

South Island pied oystercatchers
roosting at high tide.

Camera: Canon EOS 40D. *Lens:* EF400mm
f/5.6L USM. *Settings:* 400mm f/6.3 1/125
sec ISO 400. © Paul Sorrell

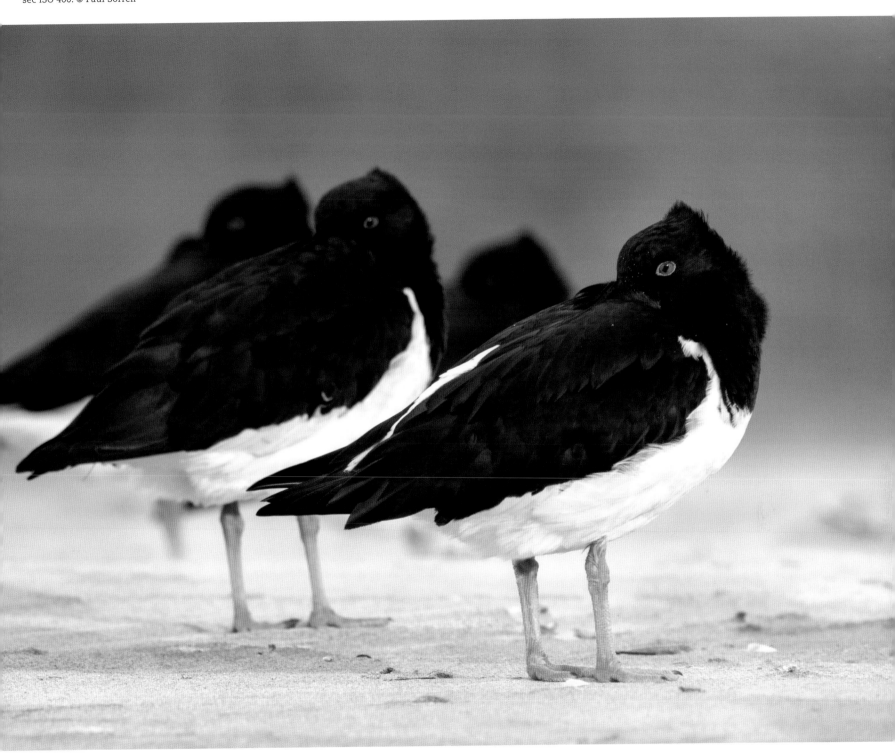

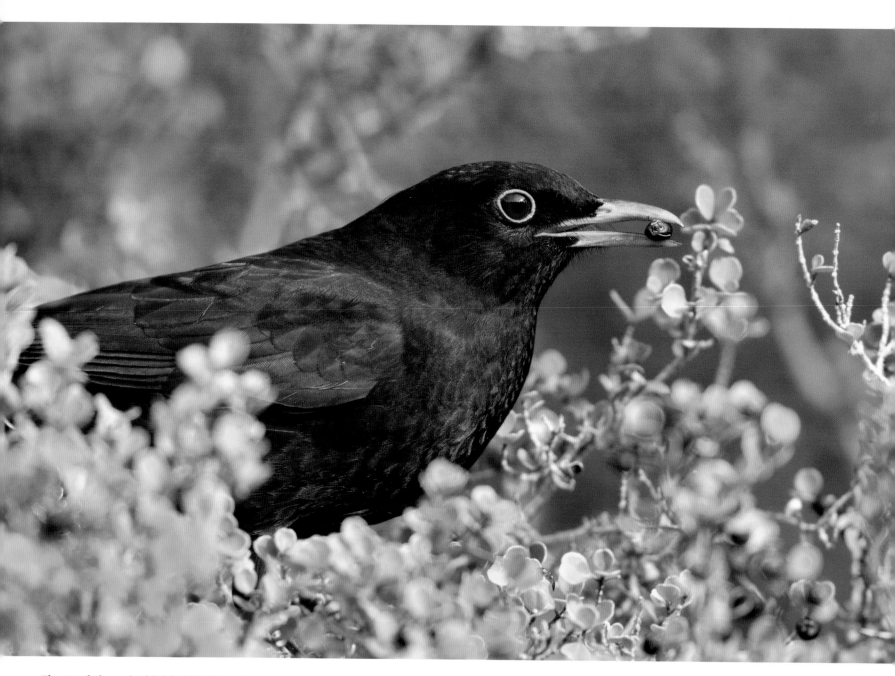

The myrtle berry in this blackbird's beak
draws our attention to its eye, which
resembles it in size, shape and colour.

Camera: Canon EOS 7D. *Lens*: EF400mm f/5.6L USM.
Settings: 400mm ƒ/5.6 1/400 sec ISO 800. © Paul Sorrell

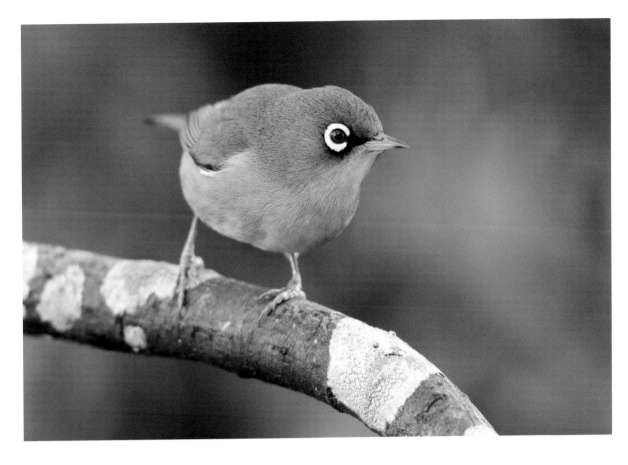

Sometimes, when you are doing post-production work on your image, the subject's eye looks dull on the screen. A simple click or two of the dodge tool (in Photoshop, for example) will restore that attractive gleam that you saw in the field!

Leaning towards the viewer, and with its eye enlarged by a ring of tiny white feathers, this silverye holds us with its inquisitive gaze.

Camera: Canon EOS 7D. *Lens:* EF400mm f/5.6L USM. *Settings:* 400mm ƒ/5.6 1/100 sec ISO 1000. © Paul Sorrell

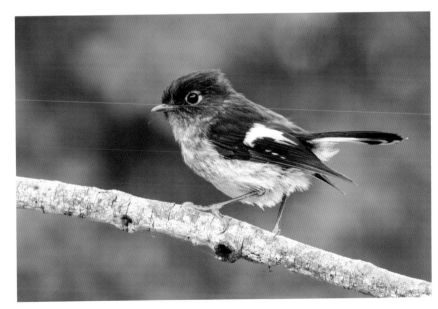

Captured at eye level, and with its head turned slightly so that a catchlight appears in the eye, this juvenile tomtit makes a satisfying image.

Camera: Canon EOS 7D. *Lens:* EF400mm f/5.6L USM. *Settings:* 400mm ƒ/6.3 1/160 sec ISO 800. © Paul Sorrell

The ideal shooting position has the bird sitting on a perch at eye level. Aiming the camera too low or into the upper branches of a large tree usually results in an awkward perspective. Sometimes you'll need to lie on the ground with your camera resting on a beanbag or other support, or with your tripod adjusted to its lowest position, placing yourself level with your subject. An image of a bird on the ground captured by a photographer standing above it is never going to be interesting!

One final point. While you are waiting for the bird to turn its head to the desired position, try to ensure that the eye also reflects the light. (You can increase your chances of success by positioning yourself so that the light is behind you and comes over your shoulder towards the bird.) In a photograph, an animal without a catchlight in the eye looks dead — it might as well be a museum specimen. Try it and see for yourself!

The
bigger
picture

Human impact on the environment
We are a part of the picture

This topic is often featured as a special category in wildlife photography competitions. Many entries show the same subjects: lovers' initials carved into tree trunks, close-ups of roadkill with traffic zooming past, gamekeepers' trophies hung up on fences … There is certainly room here for innovation — one of the most widely viewed images in this category is Marsel van Oosten's shot of a Japanese macaque luxuriating in hot springs while peering intently at an iPhone!

Marsel's media-savvy snow monkey won him the People's Choice Award at the prestigious Wildlife Photographer of the Year competition in 2014. My shot opposite won a rather more modest prize — the Human Impact on the Environment Award for 2017 in the annual wildlife photography competition run by my city museum. My picture shows a pair of juvenile kea (New Zealand mountain parrots) tussling over a discarded cigarette. It was taken in a well-visited layby on a road much travelled by tourists in the country's

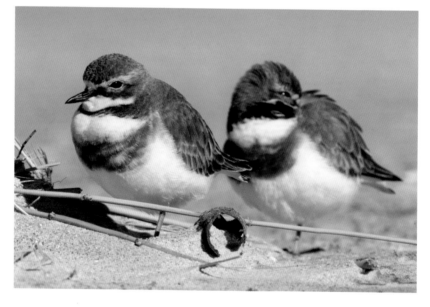

Our rubbish accumulates on beaches more readily than other habitats. From where I lay, it was impossible to photograph this pair of banded dotterels without including this piece of rusty pipe.

Camera: Canon EOS 20D. *Lens*: EF400mm f/5.6L USM. *Settings*: 400mm ƒ/11 1/250 sec ISO 200. © Paul Sorrell

deep south. By getting down low, I was able to fit both their heads in the frame as they toyed with their prize, pressing the shutter at a moment when all four eyes were in sharp focus.

My kea tale casts a sidelight on a much wider story — the relentless pace at which human settlement and activities are encroaching on

the natural world. Many wildlife photographers continue to present images of natural subjects as if these things were not happening — yet widen the frame a little and evidence of our often destructive presence is everywhere. That shot of a wild lion in what seems like remote and pristine habitat in the Serengeti disguises the reality that

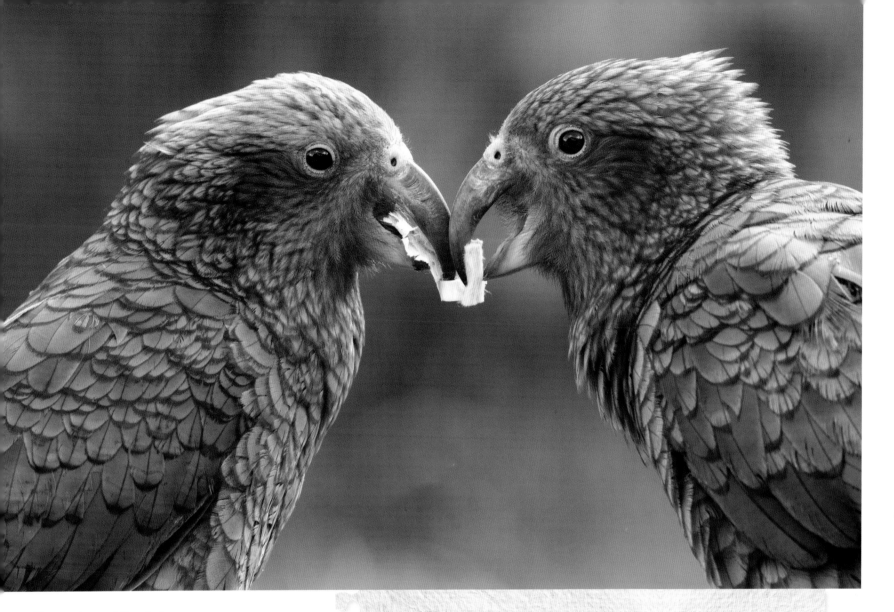

Kea are the world's only true
alpine parrots.

*Camera: Canon EOS 7D. Lens:
EF400mm f/5.6L USM. Settings: 400mm
f/6.3 1/160 sec ISO 800. © Paul Sorrell*

the person who took it was a passenger in one
of a fleet of safari vehicles that had the hapless
beast all but surrounded …

Humans and animals don't live in separate
boxes. By the way we frame our shots, we can
choose whether or not to reveal the extent of
our footprint on the planet.

KEA JUST WANNA HAVE FUN …

I was able to take this image relatively easily as the birds were
attracted to an area frequented by visitors, where buses and
cars often stop precisely to see the kea and feed them scraps.
Natural clowns, these alpine parrots know how to keep an audience
entertained with their acrobatic antics as they peck away at rubber
seals and wiper blades. (Postscript: recent signs warning against
feeding these birds are proving effective. On my last visit to the
area, feeding had stopped and the kea were nowhere to be seen.)

97

Ethics in the field
First, do no harm ...

Although I take many bird photos at Orokonui Ecosanctuary, my local reserve, there is one species — the takahē, a rare native rail — that I will always label as 'captive' as, being flightless, it has no way of leaving the reserve. By contrast, Orokonui's population of kākā, a forest parrot, can come and go as they please.

Camera: Canon EOS 7D. *Lens:* EF400mm f/5.6L USM. *Settings:* 400mm *f*/8 1/500 sec ISO 800.
© Paul Sorrell

In 2009, the photography world was shaken to the core when the winning entry in the Wildlife Photographer of the Year Awards was exposed as a fraud. The photograph, taken by a fixed trail camera, showed a wolf jumping over a rustic gate in Spain. However, someone recognized the animal's distinctive markings, and it turned out to be a trained or 'model' wolf. In 2017, the judges were embarrassed again after awarding one of the top prizes to a stunning shot of an anteater breaking into a termite mound in Brazil. The only problem was that the anteater was a stuffed specimen, borrowed from the nearby national park visitor centre!

While most of us will never have to deal with situations involving such high stakes, few of us have not been tempted to 'cross the line' to get that perfect shot.

The problem is that different people draw that line in different places. According to a code of conduct for photographing birds produced by a national ornithological society, we should avoid 'feeding attractants' — but this would make miscreants of the millions of bird-lovers who stock their garden feeders with peanuts and fat balls. I see nothing wrong with putting out natural food, preferably collected from the local area, to attract birds to your chosen site. The same goes for using roadkill to stake out elusive raptors. However, most people would draw the line at the use of live bait — for example, throwing live mice into snowdrifts where snowy owls are hunting.

Another controversial area is the playback of bird calls. In my view, this is an acceptable way of gaining the attention of many common birds, but should be used in small doses, and not at all during the breeding season. Without using calls, it would be almost impossible to photograph birds like the migratory shining cuckoo — often heard in summer, but seldom seen.

As far as remotely controlled camera traps or trail cameras are concerned, I have no quarrel with them. To site a camera trap effectively, a good deal of knowledge and observation of the target species is required. It's a good option for shy, rare or nocturnal animals. The best photos I've seen

of snow leopards have been taken remotely at scent-marking sites in their home territory in the Himalayas. Leading wildlife photographers are increasingly turning to this technology, which enables animals to be photographed at unusual angles or with a level of intimacy not possible using conventional methods.

Of course, you could save yourself a lot of trouble by simply training your lens on a captive snow leopard, rather than spending weeks or months tracking one down in the wild. The ethical issue at stake here is transparency. It's fine to photograph captive specimens or zoo animals, as long as the resulting images are captioned as such. Captions and titles are important for other reasons, too. If an animal or bird that you've photographed in the wild is rare or vulnerable, you may not want to reveal its precise location, especially if you are posting your images in a public forum.

The code of conduct mentioned above also suggests that intending photographers get permission to enter private land and obtain any permits needed. You should also consider others who are watching or photographing birds nearby — respecting the etiquette of the field.

Encompassing all these cautions and suggestions is the point that, in any interaction with wildlife, the animals' welfare is paramount. This means that, as photographers, we should approach our subjects with respect and care, taking pains to minimize our impact and backing off if they show any signs of stress. Special care is needed around nests, as birds disturbed while nesting could abandon their eggs or young or attract the attention of predators.

The birds always come first!

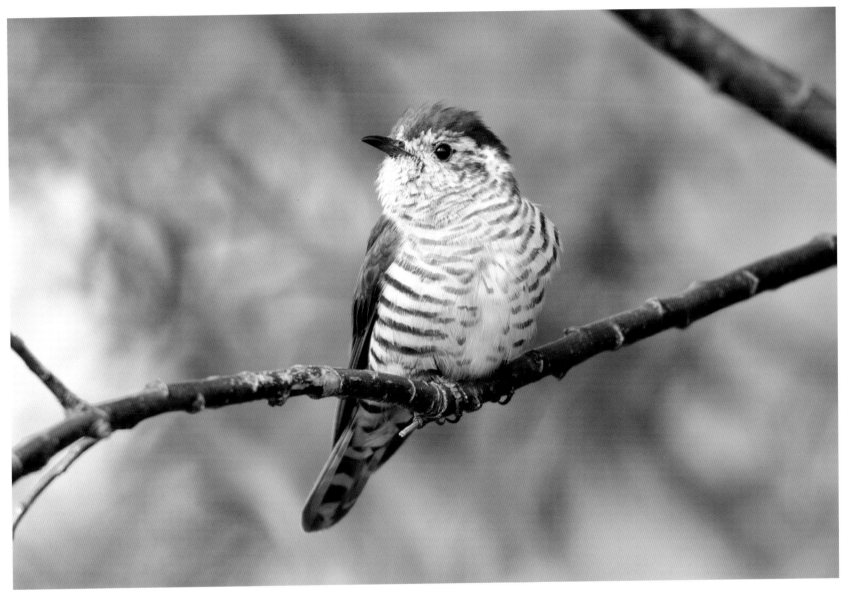

Summer visitors to New Zealand and Australia, shining cuckoos are often heard but seldom seen.

Camera: Canon EOS 7D. *Lens:* EF400mm f/5.6L USM. *Settings:* 400mm ƒ/5.6 1/400 sec ISO 400. © Paul Sorrell

At my local reserve, kākā are free to stay or fly away — they are truly wild birds.

Camera: Canon EOS 7D. *Lens:* EF400mm f/5.6L USM. *Settings:* 400mm ƒ/6.3 1/320 sec ISO 800. © Paul Sorrell

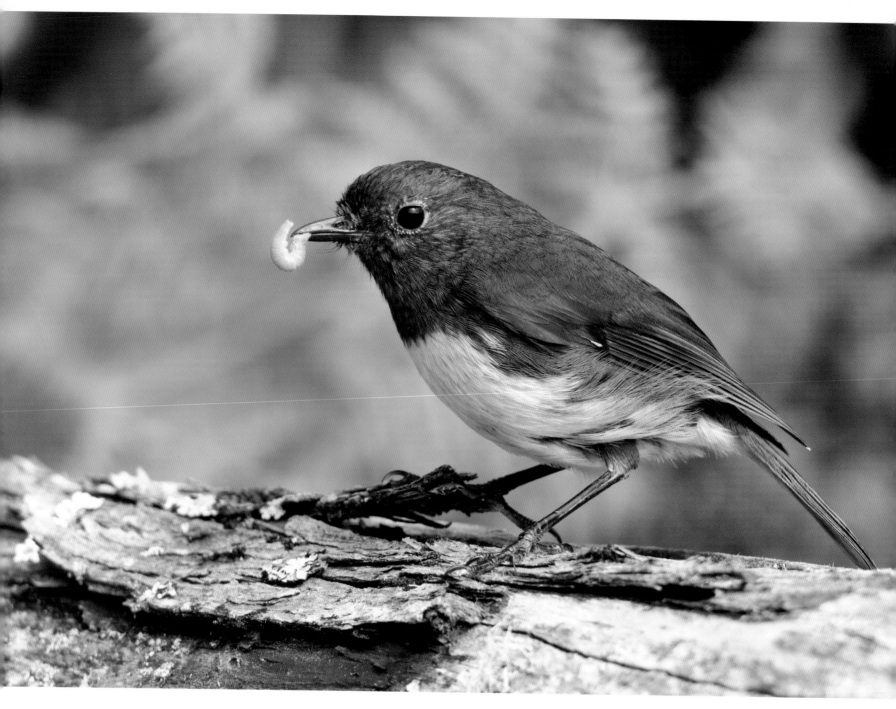

This South Island robin was
attracted by caterpillars gathered
from my vegetable garden.

Camera: Canon EOS 7D. *Lens:* EF400mm
ƒ/5.6L USM. *Settings:* 400mm ƒ/6.3 1/640
sec ISO 400. © Paul Sorrell

Fixed cameras with wide-angle lenses are often used to capture close-up images of birds like this great grey owl in a spruce forest.

Shutterstock © Ondrej Prosicky

Getting noticed
Publications and competitions

As you gain confidence as a photographer, you will want to find ways of sharing your work with others. One way of doing this is to mount an exhibition in a local café or art gallery, but it can be time-consuming and costly to get your prints matted and framed and pay gallery costs.

A good starting place are photographers' community websites like Flickr and 500px, where you can have your own page and build up a portfolio of your images. You can progress from there to a personal website where you can showcase your best work and even offer it for sale. Having your own site will also allow you to document your activities, such as trips and publications, and perhaps maintain a blog that will allow you to keep a record of your various shoots and field trips. Among other subjects, your blog could cover a species at risk or document a particular location, such as your local park or botanic garden.

Your online blog may well lead you to the next step — writing up a project for a magazine,

whether focused on wildlife or photography or another relevant area such as travel. Before approaching national magazines, it's worth exploring outlets closer to home. For example, I've written several pieces for my local newspaper about the birds in the nature reserve on the edge of the city, where I do a lot of my photography. To increase your chances of publication, you could think about teaming up with a writer, but it will give you a big advantage if you can write as well as take great wildlife images. Make a list of magazines you'd like to appear in and send the editor a pitch for your story.

As for photo competitions, there are almost too many options to choose from. Magazines like *BBC Wildlife, National Wildlife* (in the US) and the online *Wild Planet Photo Magazine* solicit readers' images and sometimes offer attractive prizes. There is a growing number of wildlife photography competitions including the British Wildlife Photography Awards and, in the US, Nature's Best and the Audubon Photography Awards.

Niche contests include the Comedy Wildlife Photography Awards (see pp. 108–113) and the Ocean Art Underwater Photo Competition (annually since 2010). Antipodeans are served by the Australian Geographic Nature Photographer of the Year competition held each year by the South Australian Museum. At the top of the tree sits the Wildlife Photographer of the Year Awards, sponsored by the Natural History Museum in London and the Holy Grail for all serious nature photographers.

Realistically, you might like to begin by entering one of the many local competitions in your home area. These will range from the competitions and exhibitions organized by photographic societies and camera clubs to events run by local art and cultural institutions. These contests usually include a wide range of categories, such as animal portraits, animal behaviour, flora, human impact on the environment, threatened species and abstract nature art. Some include a portfolio section that gives entrants the opportunity to showcase the breadth and quality of their work.

This photograph of two yellow-eyed penguins coming ashore on a New Zealand beach has been widely published. The vibrant colours, the front bird's full-throated call and flippers held out in an apparent gesture of welcome, and the play of light on the wet rocks all add to the image's appeal.

Camera: Canon EOS 20D. *Lens:* EF400mm f/5.6L USM. *Settings:* 400mm *f*/8 1/160 sec ISO 400. © Paul Sorrell

Professional prospects
Can you make a living from your work?

Like many other occupations, professional wildlife photographers have had to adapt to changing times. Gone are the days when a pro could make a living by supplying picture agencies with blue-chip images of polar bears in the High Arctic or lions in the Serengeti.

While a handful of professionals still range the globe collecting iconic nature images, they are coming under increasing pressure from an army of talented amateurs for whom digital technology has opened up new worlds. The numerous stock sites on the web (like Alamy, Shutterstock and Unsplash) are full of high-quality images which often sell for just a few cents.

Nevertheless, most professionals maintain impressive websites where they post large catalogues of images, constantly augmented, often supplemented by a selection of their best work for sale as prints. They also feature their work on specialist image libraries like Ardea, Nature Picture Library and RSPB Images.

However, rather than mounting costly expeditions to exotic locations, many professionals have added alternative activities to their repertoire, few of which involve taking pictures. These include running workshops, giving talks (the international photography lecture circuit draws many of the big names in the field), and leading small photo tours to wildlife-rich locations where their specialist knowledge and experience comes to the fore. Others hire out permanent hides that put paying visitors within lens reach of charismatic birds like kingfishers and owls. A favoured few take the sponsorship path, becoming 'ambassadors' for top companies like Canon and Nikon.

Despite these new outlets, very few people manage to make a living out of wildlife photography. Those that do will tell you that, for every hour in the field, many more are spent behind a desk, processing their massive back catalogue or simply running the business. Most of us will need to hang onto our day jobs —

and we may not be especially concerned with making money out of what, for many nature photographers, is essentially a hobby. But whether you are displaying prints in your local café, preparing an article for a tourism website, or thinking about producing postcards or a calendar, there are still opportunities to make a few dollars.

The important thing is to keep thinking outside the square.

Getting the most out of your website

Whether you're an amateur or a professional, you'll want to maximize the impact of your website. You can have one designed by experts, or you can build your own site using templates supplied by companies like SmugMug, Wix and Squarespace. If you want your images to be found, then you need to be aware of something called search-engine optimization (SEO). That means you should include as many relevant terms

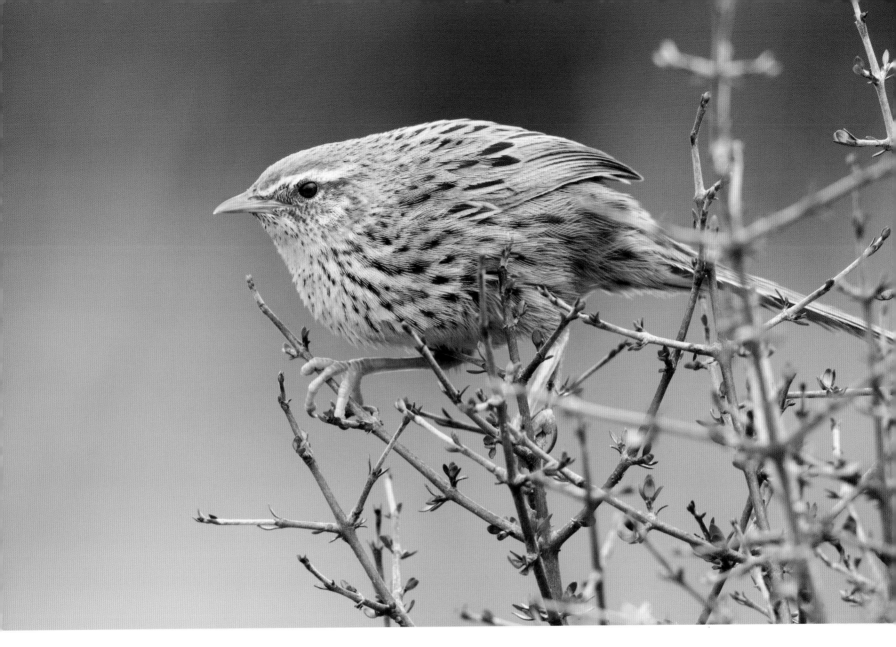

as you can in your text, especially in headings and straplines, include links to other sites (such as social media) and label every image with appropriate keywords. These should go beyond the obvious — species names and locations — to include abstract qualities and concepts that searchers (preparing advertising copy, for example) may be looking for such as 'tranquility', 'loyalty', 'irritation' or 'patience'. And don't forget to update your site regularly!

Today, most wildlife photographers are amateurs or semi-professionals who concentrate on local subjects. This fernbird was photographed in a reserve near my home.

Camera: Canon EOS 7D. *Lens:* EF400mm f/5.6L USM. *Settings:* 400mm f/6.3 1/800 sec ISO 800. © Paul Sorrell

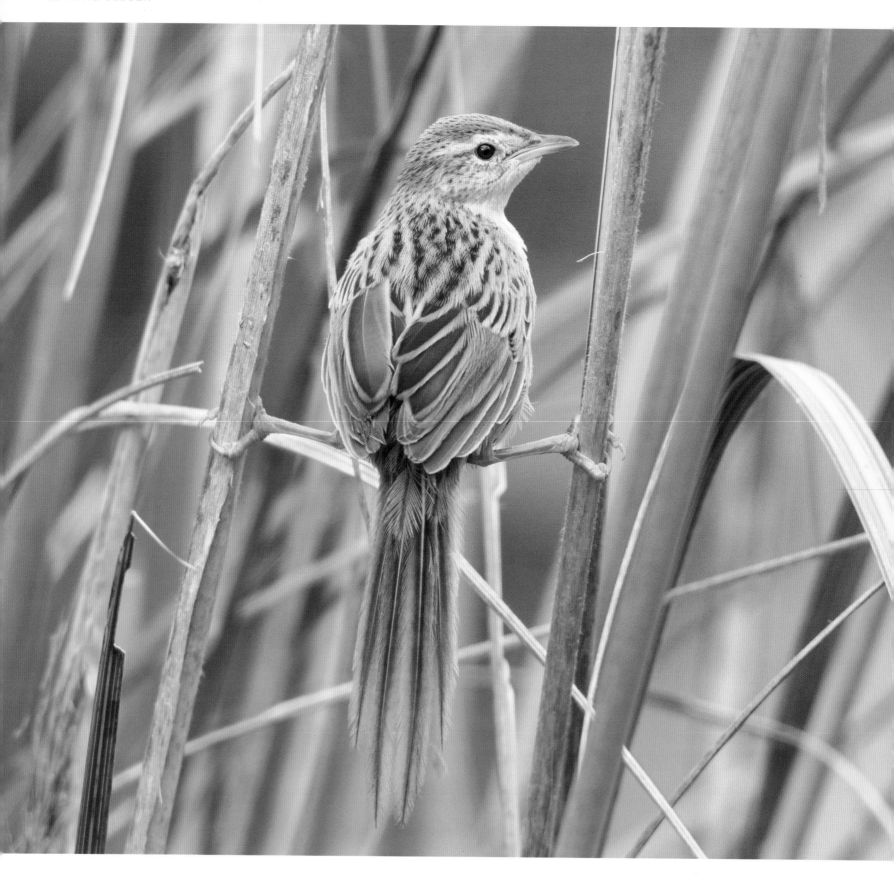

Anthropomorphism and humour
You gotta laugh ...

Wildlife documentaries have come a long way since the Disney-style efforts of the 1960s and 1970s, with their talking animals and whimsical attempts to endow wild creatures with human emotions and behaviour — or anthropomorphism, to use the technical term.

But wildlife images, like television documentaries, need to forge an emotional connection with their audience, and no subject appeals to us more than those that seem to reflect some aspect of human behaviour or the human condition in general. A dash of humour is an added bonus. Animal behaviour or expressions that are 'cute' will always be appealing — the trick is to know where to draw the line.

Images suggestive of romantic attachments are always very popular. This may explain why people love great crested grebes, with their elaborate courtship rituals and very visible pair bonding. So it was the icing on the cake when I discovered the heart shape formed by the birds' necks in one of my photographs of a pair of these handsome

waterbirds taken at an artificial wetland on the outskirts of a city (see p. 37).

(see p. 37).

If the action you have captured happened in the wild, without you manipulating the situation, then it's probably acceptable. I remember seeing a photo of a row of tiny nestlings, beaks agape as they noisily begged for food, which had obviously been plucked out of the nest moments earlier and lined up on a twig. Very appealing on one level, but not acceptable in any circumstances.

I have numerous pictures of very cute baby tomtits and other juvenile birds (like bellbirds and fernbirds), always photographed in natural situations, and they always draw plenty of 'likes' on the photographers' community site (500px.com) where I post my images. I've also taken pictures of a wrybill 'sneezing' (can birds sneeze?), a fernbird doing the splits and a female tomtit whose head is obscured by the large collection of feathers she is carrying. (Okay, I provided the feathers on this occasion, having observed that she was in the final stages of nest-building.)

While appearing ungainly and even comic, this is a normal posture for fernbirds to adopt.

Camera: Canon EOS 7D. *Lens*: EF400mm f/5.6L USM. *Settings*: 400mm ƒ/6.3 1/500 sec ISO 800. © Paul Sorrell

It's hard to plan photographs like this — they mostly just happen. But not only are they enormously popular (what would the internet be without all those funny animal clips?), they also have the potential to promote a serious conservation message.

This image of a courting pair of great crested grebes seems tailor-made for a Valentine's Day card!

Camera: Canon EOS 7D. *Lens:* EF400mm f/5.6L USM. *Settings:* 400mm *f*/6.3 1/500 sec ISO 800. © Paul Sorrell

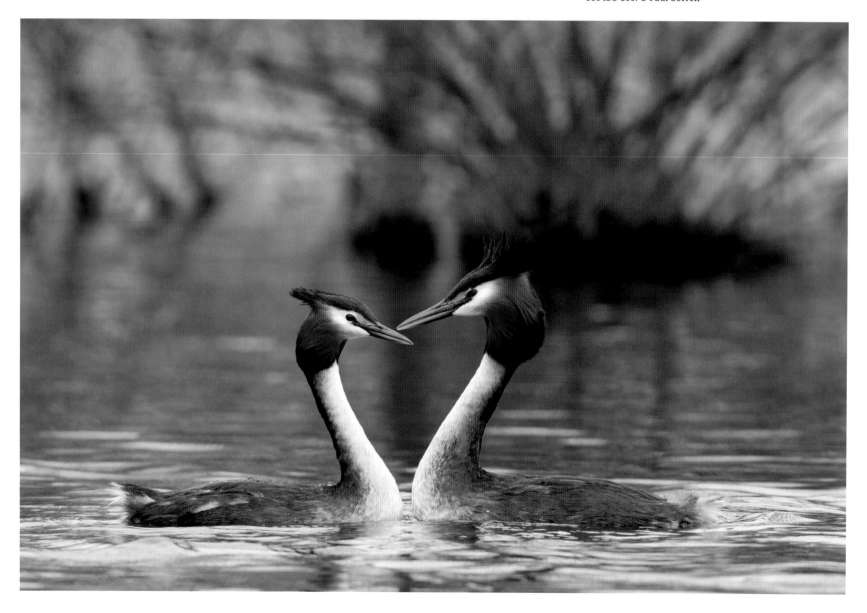

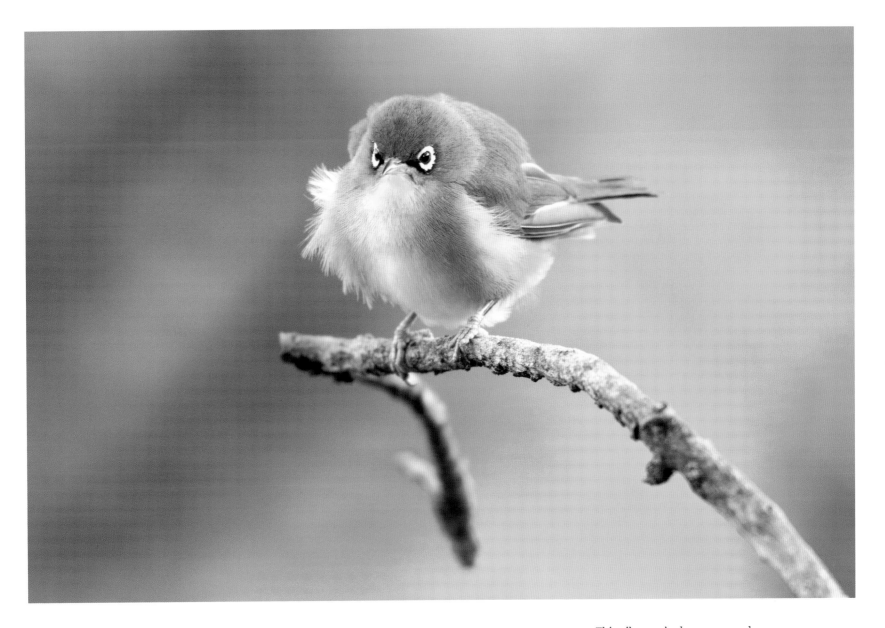

This silvereye's clown eyes and dishevelled plumage are bound to provoke a smile.

Camera: Canon EOS 7D. *Lens:* EF400mm f/5.6L USM. *Settings:* 400mm ƒ/5.6 1/100 sec ISO 800. © Paul Sorrell

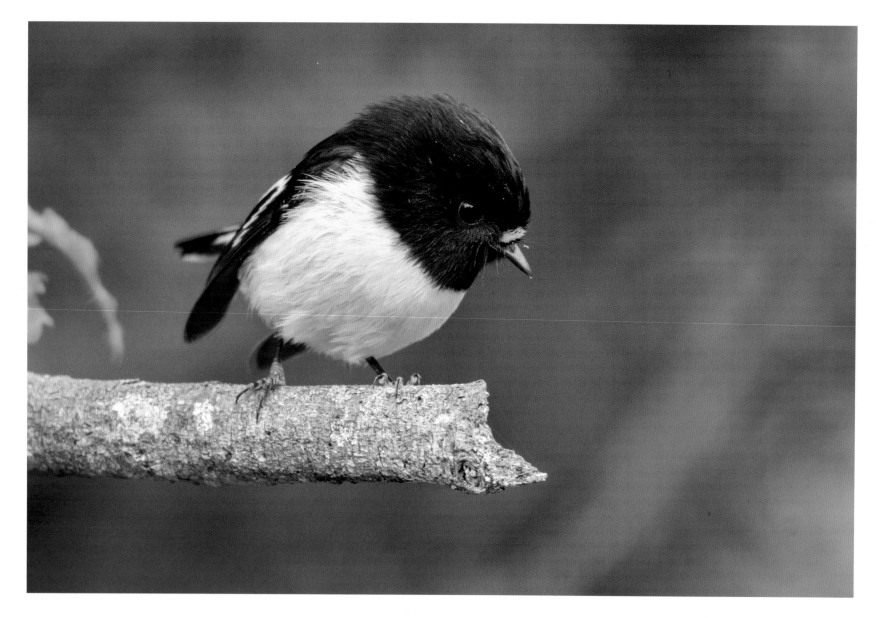

My long-term observations of tomtits have enabled me to take a number of comic shots, including a 'walking the plank' scenario and a female who has collected a big beakful of feathers to line her nest (right).

Camera: Canon EOS 7D. *Lens:* EF400mm f/5.6L USM. *Settings:* 400mm ƒ/5.6 1/30 sec ISO 1000. © Paul Sorrell

Camera: Canon EOS 7D. *Lens:* EF400mm f/5.6L USM. *Settings:* 400mm ƒ/6.3 1/160 sec ISO 640. © Paul Sorrell

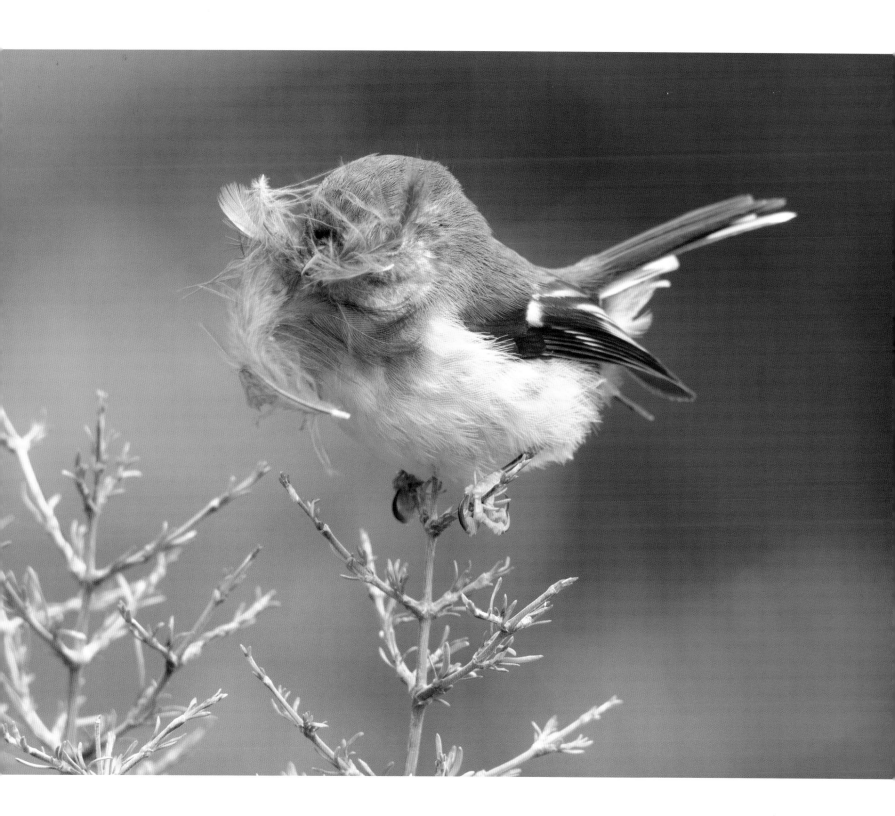

113

Birds as art
What makes a photo beautiful?

The camera illustrates reality, and often that can be breathtaking, but that's all it does.
—Michael McCarthy

Despite my admiration for Michael McCarthy as a nature writer, I can't agree with this statement, made in a newspaper article where he argues for the creative superiority of wildlife artists over wildlife photographers. A thoughtful photographer will exercise as much judgement with regard to perspective, lighting, composition, colour and setting as any artist. Like many well-known artists, the best photographers can be distinguished by their trademark style.

But perspective, lighting and so on are formal features of an image. Can photography evoke a sense of mystery, something that transcends the sum of its parts? Can nature photography do this? Can an image aspire to the condition of a poem, whose full meaning can't be translated into prose? Can photography — as art surely can — make us

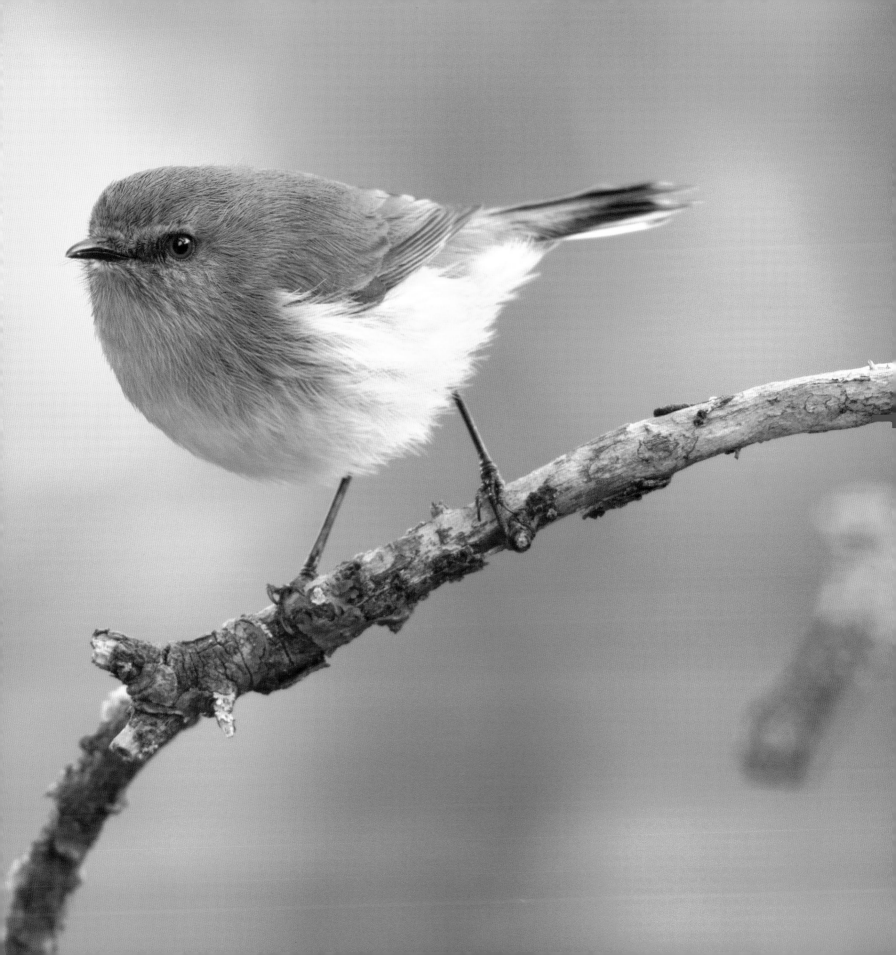

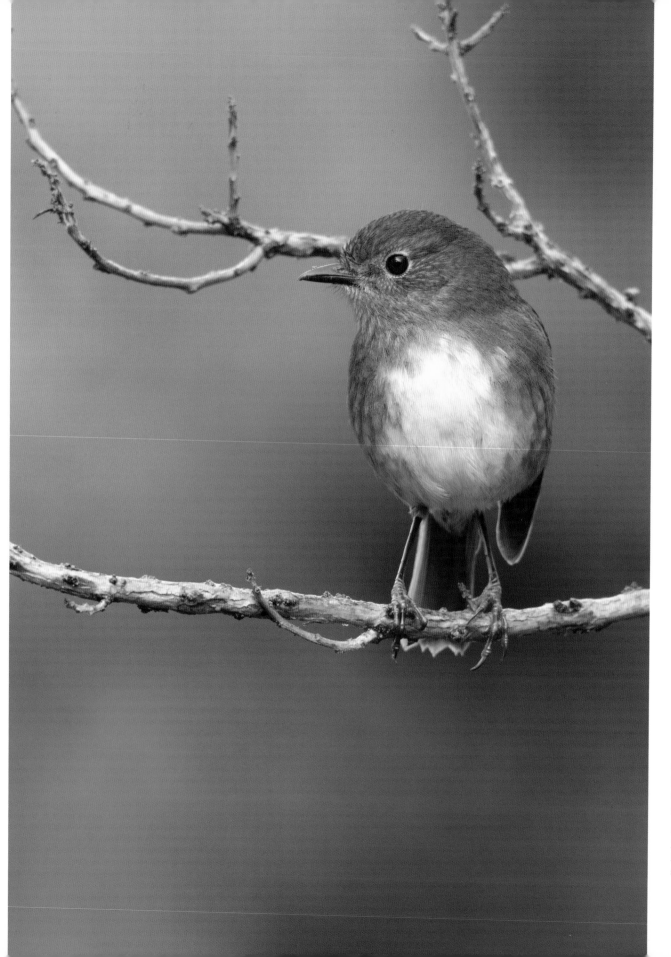

(Previous page)
The colourful, diffused background and a simple, striking subject combine to make this image of a grey warbler graphically arresting.

Camera: Canon EOS 7D.
Lens: EF400mm f/5.6L USM.
Settings: 400mm ƒ/5.6 1/160 sec ISO 800. © Paul Sorrell

A robin sitting on a fuchsia twig creates a clean, minimalist effect.

Camera: Canon EOS 7D.
Lens: EF400mm f/5.6L USM.
Settings: 400mm ƒ/6.3 1/320 sec ISO 640. © Paul Sorrell

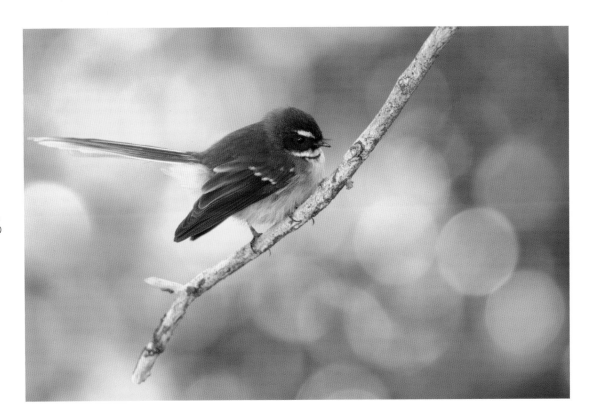

The low afternoon sun has created an attractive backdrop of out-of-focus highlights (or bokeh) for this pied fantail.

Camera: Canon EOS 7D. *Lens*: EF400mm ƒ/5.6L USM. *Settings*: 400mm ƒ/5.6 1/100 sec ISO 800. © Paul Sorrell

think differently about its subject, allowing us to see familiar things in a new way?

For wildlife photographer Denise Ippolito, evidence of creativity is seen in the kind of 'minimalism' that is found in black-and-white and high-key photography, and in the use of negative space that can be suggestive of emotional as well as formal relationships in an image. For Ippolito, the use of slow-motion blur; the inclusion of atmospheric effects such as rain, snow, mist and water; and the creation of patterns through the manipulation of line, form and colour are all conducive to the artistic handling of subject matter. Such elements are prominent in the 'fine art' prints offered for sale by many professional nature photographers.

That said, there are many different understandings of what makes a successful wildlife photograph. While local camera clubs give wildlife photography a special status (competitions are typically divided into 'nature' and 'open' sections), the rules can often be rigid. For example, showing evidence of the human environment in a nature image is still often frowned on. Old-school judges will still mark you down if your photograph fails to sufficiently resemble a species plate in a field guide, with the whole bird showing and everything in sharp focus.

Attitudes are changing. International competitions like the Wildlife Photographer of the Year have greatly enlarged our definitions and understanding of nature photography and have opened up approaches to wildlife imagery

that go far beyond the familiar offerings of the club scene. The level of ingenuity and creativity on display in such contests is astonishing and inspirational. Following these top competitions, as well as blogs by leading nature specialists such as Marsel van Oosten, Will Burrard-Lucas or Suzi Eszterhas, will keep you abreast of the latest developments in the discipline, whether technical (such as the use of drones) or aesthetic.

Tools
of the
trade

The fast autofocus on my Canon 7D had no difficulty
capturing the antics of this very active tūī in my back garden.

Camera: Canon EOS 7D. *Lens*: EF400mm f/5.6L USM. *Settings*: 400mm
ƒ/5.6 1/400 sec ISO 640. © Paul Sorrell

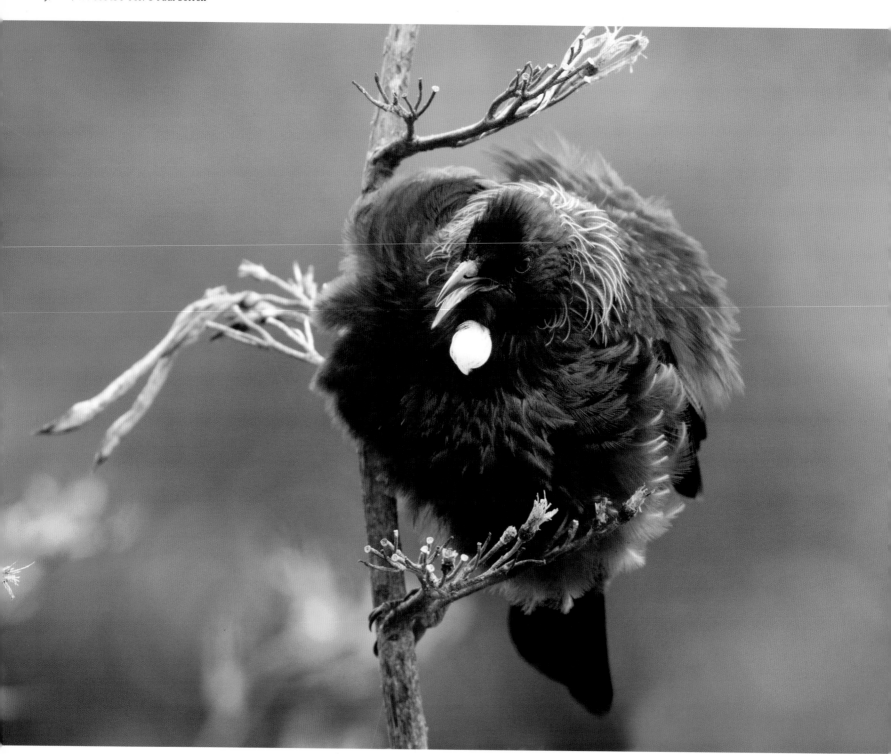

What's the right camera for me?
There's something for everyone

Ask people to describe a typical wildlife photographer and they will conjure up an image of an intrepid adventurer (usually male), stalking off into the wilderness laden down with tripod, heavy backpack and a chunky camera (either a Canon or a Nikon) bearing a massive super-telephoto lens.

Although such stereotypes can still be identified, in the last few years wildlife photography has undergone radical changes with the advent of new camera systems that are lighter, more compact and more affordable than their predecessors.

At the most basic end of the spectrum sits the ubiquitous smartphone camera. Although these cameras are incorporating increasingly sophisticated technology, their limited focal length and very wide angle of view means that unless you can get very close to your subject, they are of little use to bird photographers. For nature work, phone cameras are best kept for landscapes, where the results can be impressive.

Next in the hierarchy is the point-and-shoot or 'bridge' camera. For the casual hiker or day-tripper, these cameras can be tucked into a backpack and pulled out when a wildlife opportunity presents itself. If you are at all serious, you'll need a 40x to 60x optical zoom to capture birds, preferably in a model with the larger (1-inch) sensor. The results should be more than adequate to post on the internet or make a medium-sized print. Point-and-shoot cameras come in two varieties: compact super-zooms with retractable lenses, like the Sony Cybershot and the Panasonic Lumix range, and bulky super-zooms like the Canon Powershot and the Nikon Coolpix models.

For the serious wildlife photographer, DSLRs (digital single lens reflex cameras) still hold the field — but only just. Mirrorless cameras (which lack the mirror that flips up every time the shutter is pressed on a DSLR) are making big inroads into top-end nature photography, with their range of sensor types and lenses proving attractive to

An inquisitive bird like a robin may allow you to approach close enough to take a picture on your mobile.

Capturing the handover of food may require the use of continuous shooting mode. Here, a white-fronted tern feeds an arrow squid to its chick.

Camera: Canon EOS 50D. *Lens*: EF400mm f/5.6L USM. *Settings*: 400mm ƒ/7.1 1/640 sec ISO 200. © Paul Sorrell

practitioners wanting greater ease and flexibility. Because animals can move fast and unpredictably, wildlife photographers need cameras with fast autofocus and shooting capabilities, as well as good low-light performance, compatibility with a range of lenses, durable camera bodies and long-life batteries.

Although DSLRs (and their mirrorless equivalents) score top marks in all these areas, there are other factors to be considered. Whereas full-frame sensors perform better in low light due to their superior light-gathering power, cropped (APS-C) sensors give greater reach. So on my Canon 7D, my 400mm lens has an effective focal length of 640mm — a magnification factor of 1.6.

Micro Four Thirds (MFT) cameras are now making a big impact. Although they've been around for a while, it's only in the last few years that pro-level photographers have taken them seriously. Because their small sensors allow 2x magnification (giving a 300mm lens an effective range of 600mm), they can take smaller and lighter lenses, although this also means that they fare less well in low-light conditions. However, they are now pegging level with their heftier rivals in terms of autofocus speed and accuracy, a major consideration for wildlife photographers.

MFT manufacturers — including all the brands mentioned above — are also developing a range of super-telephoto lenses and teleconverters for their cameras, and are pioneering some innovative technology including in-camera image stabilization, 4K video, silent shutters, focus stacking (for macro work) and panorama mode.

There's never been so much choice!

TOP TIP A camera's maximum 'burst' speed is measured in frames per second (fps). While 8fps is probably the minimum for wildlife photographers, many of the cameras discussed here are capable of much faster rates. However, unless rapid action is unfolding — such as a parent bird flying in to feed her chick — I avoid 'machine-gunning' the subject and prefer a more considered approach. And because multiple exposures may take a few seconds to be saved to the memory card, it's worth investing in more expensive cards with higher buffer speeds.

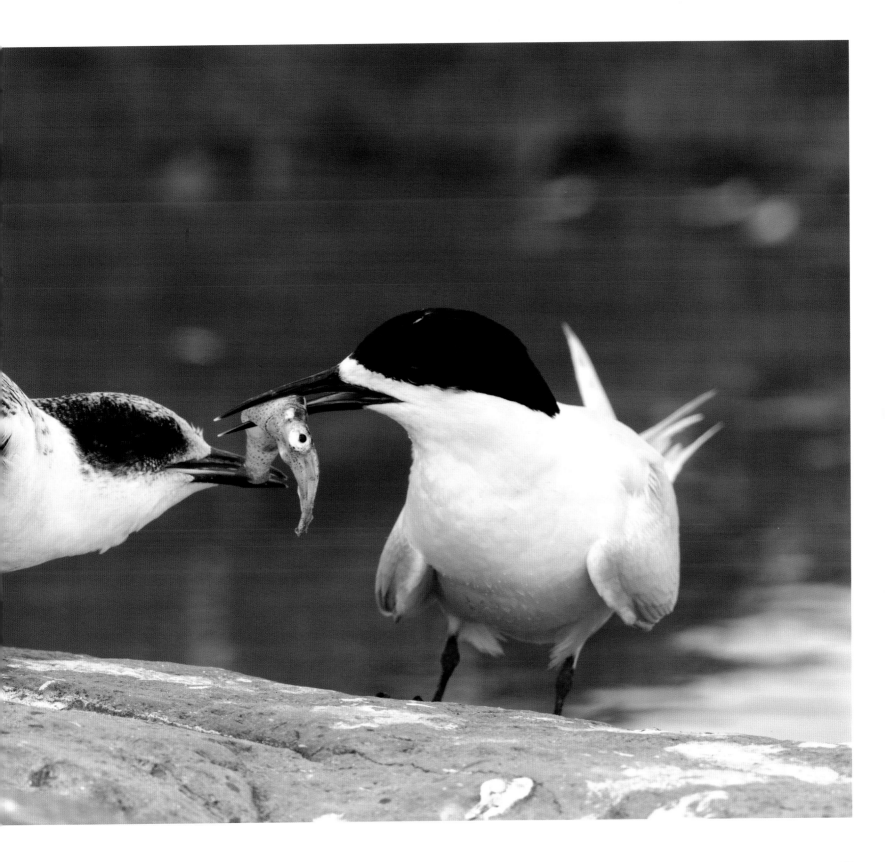

What's in my camera bag? Everything but the kitchen sink …

I recently led a hands-on workshop for an audience of budding nature photographers. The first thing I did was to show them my gear and unpack my camera bag. I did this with some hesitation, as I wasn't completely sure what I might find. As I explained to the group, I recently recovered a shrivelled apple from a remote pocket that had probably been there for a couple of years!

The largest space in my bag, a sturdy Lowepro that has stood up to years of ill-treatment, is reserved for my DSLR camera, with long lens attached. The padded compartments surrounding it contain a couple of lens adapters — a 1.4 times extender, to give some extra reach, and an extension tube for small bird work that cuts down the minimum focusing distance of my fixed 400mm lens from 3.4 to 1.8 metres (11 to 6 feet). The final piece of hardware is a 28–135 mm medium-range lens — useful when I have a larger subject in my sights. The remaining compartments contain a pair of thin merino gloves, a balaclava for extra-cold weather and a length of camo material that I can drape across my hat or use as a scarf.

Various pockets in the interior of the bag contain a lens-cleaning kit (blower brush, optometrist's lens cleaner and microfibre cloths), a bird caller and an old toothbrush (for cleaning hard-to-reach spots). Two small zip pockets hold spare batteries and memory cards.

The main outside pocket contains a plastic tub for holding insects (see below) and a water bottle (make sure it's leakproof); it also has room for my lunch, as well as a small pair of binoculars that I use for spotting potential subjects. Recently I have added a small, weatherproof Bluetooth speaker to use with my smartphone when playing back bird calls to attract subjects. This part of my pack can get quite crowded! An outside Velcro pocket contains a multi-purpose tool (a Leatherman) and — at the opposite end of the spectrum — a bag of feathers (see p. 109).

Finally, a deep but narrow compartment at the rear of the pack carries a thin coat that offers some protection in the rain, an assortment of plastic bags, including one with a hole in the bottom that can be drawn over the lens and camera to protect them from a passing shower, and a large folded sheet of heavy plastic that can double as a groundsheet and a landing pad for insect bait harvested by beating the bushes!

If I need anything else, I'll have to invest in a bigger bag …

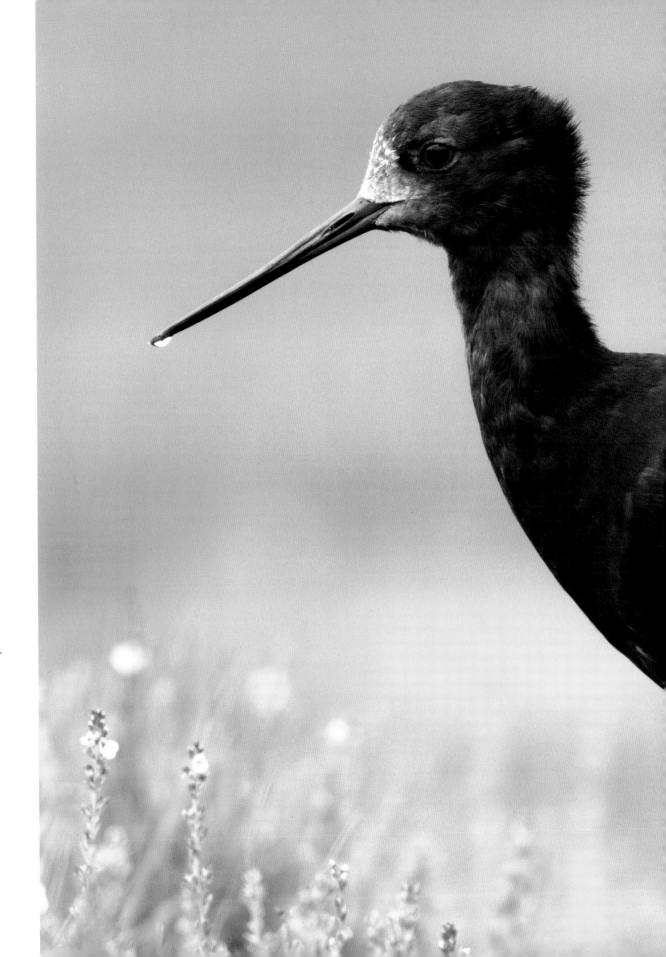

A black stilt, the world's rarest wading bird, photographed in its home in New Zealand's Mackenzie Basin.

Camera: Canon EOS 7D. *Lens*: EF400mm f/5.6L USM. *Settings*: 400mm ƒ/5.6 1/1600 sec ISO 800. © Paul Sorrell

TOP TIP Get to know your gear intimately. Wildlife photography often requires fast reaction times, so learn to use the camera controls intuitively, without needing to take your eye away from the viewfinder. Choosing aperture or shutter speed, selecting active autofocus points and setting exposure compensation and ISO levels should all become second nature.

A white-fronted tern chick and its parent at a colonial nesting site on a rock stack.

Camera: Canon EOS 50D. *Lens:* EF400mm f/5.6L USM. *Settings:* 400mm ƒ/8 1/500 sec ISO 200. © Paul Sorrell

TOP TIP Condensation inside the lens elements can be a major problem for outdoors photographers, as I've learned to my cost, often putting your gear out of action for days at a time. The problem can be avoided by not exposing the lens to sudden changes in temperature and humidity. So, on returning from a trip on a cold, damp day, leave your camera zipped up in your bag for a few hours after you come inside. Don't forget to first remove the memory card if you want to back up your photos, and the battery if it needs to be charged.

A female tomtit posing with a feather I left on this coprosma bush in the hope that she would pick it up to line her nest. I carry a small bag of feathers in my backpack for this purpose.

Camera: Canon EOS 7D. *Lens*: EF400mm f/5.6L USM. *Settings*: 400mm ƒ/6.3 1/200 sec ISO 640. © Paul Sorrell

Manipulation and processing
Least is best

Manipulation has always been a dirty word. You sometimes hear people say that digital photos should be left the way they came out of the camera, without any kind of processing. But, especially if your camera is set to shoot in Raw (see below), your in-camera images are not technically finished and require some post-processing via a software editing program like Lightroom or Photoshop.

That said, in theory at least, wildlife photography calls for the bare minimum of intervention after the shot has been captured. This is a question of ethics — in the realm of the computer rather than the field (see pp. 98–103). According to naturalist and photographer Mark Carwardine, we should 'strive to represent our subjects as faithfully as possible'. So how much manipulation is acceptable? Is it alright to remove an unsightly twig from the edge of the frame? (In my view, that's okay.) What about cloning out a leg ring? (That would be a step too far for me; I'd try to shoot the bird so that the ring was concealed if I felt it was a problem.)

Most competitions have strict rules about the extent to which nature images can be modified. The guidelines for the natural history section of the 'festival of photography' held each year by my local photographic society are typical on this point: 'Any enhancement cannot significantly alter the original scene and should respect the structural and scientific integrity of the subject and the actual environment of which it is part.' The Wildlife Photographer of the Year competition requires entrants 'to report on the natural world in a way that is both creative and honest'. Standard digital adjustments and 'minor cleaning work' are permitted provided that 'they do not deceive the viewer or misrepresent the reality of nature'.

The sky above this pied oystercatcher needed a little darkening.

Camera: Canon EOS 7D. *Lens:* EF400mm f/5.6L USM. *Settings:* 400mm ƒ/5.6 1/640 sec ISO 400. © Paul Sorrell

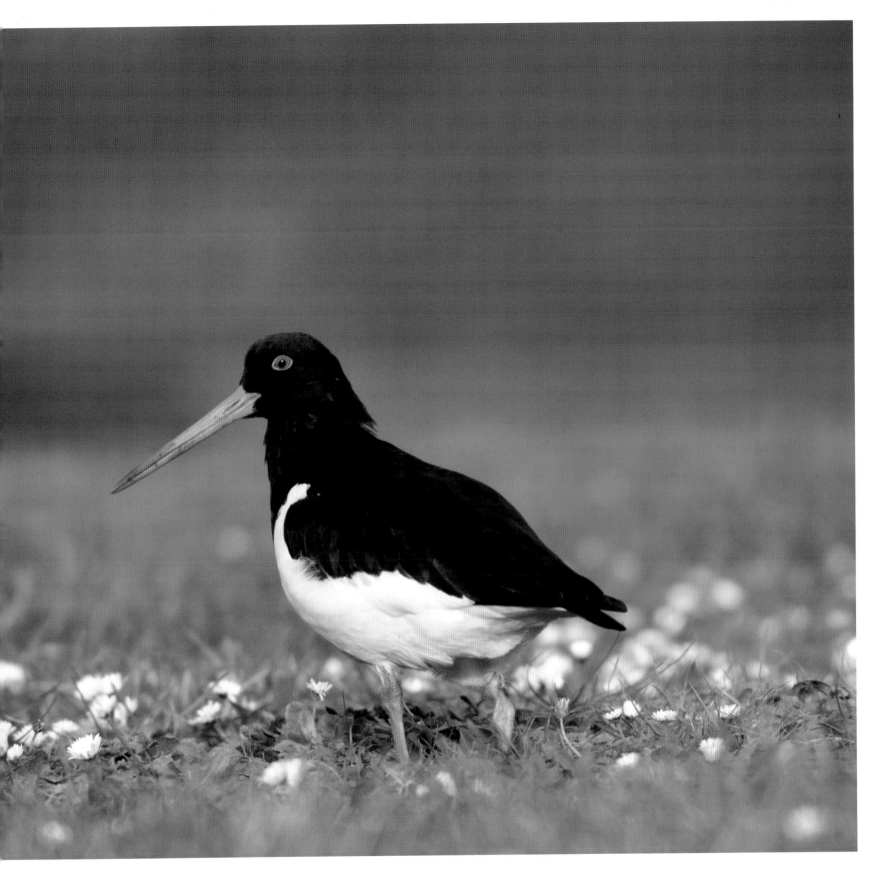

HANDY HACK

Because my editing software, Photoshop Elements, lacks a dodge and burn tool, I use a workaround, especially to slightly darken background areas that might otherwise be distracting. First, create a new layer in 'overlay' mode, and tick the '50% gray' box. Set 'colour' to black or white depending on whether you want to darken or lighten the tones. Then use the brush tool to loosely paint over the area in question, with opacity set to around 9 per cent. Keep on applying the brush until you achieve the desired result. It's easy and it works!

This tomtit is sitting on a broadleaf with highly reflective leaves, which I have dulled down using my Photoshop Elements workaround.

Camera: Canon EOS 7D. *Lens:* EF400mm f/5.6L USM. *Settings:* 400mm ƒ/5.6 1/100 sec ISO 1000. © Paul Sorrell

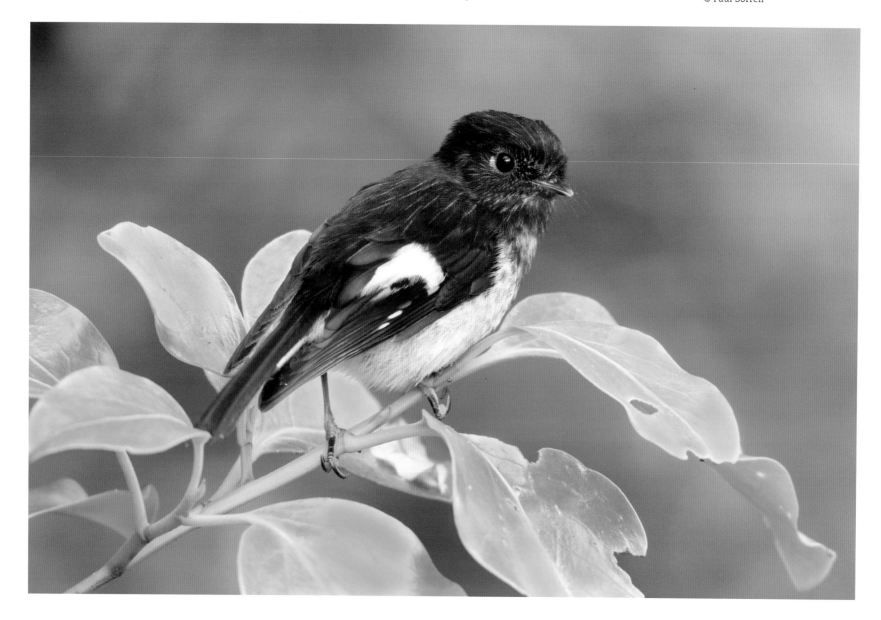

A male rock wren proudly sporting its leg rings, Fiordland National Park.

Camera: Canon EOS 7D. *Lens:* EF400mm f/5.6L USM. *Settings:* 400mm ƒ/5.6 1/320 sec ISO 800. © Paul Sorrell

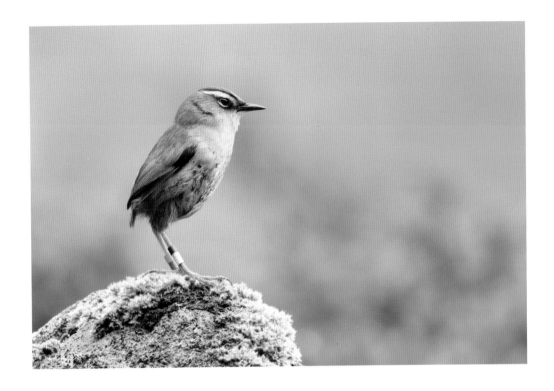

My own post-capture processing regime is as minimal as I can make it — partly because I want to represent the truthfulness of what I saw in my final image and partly because I want to spend less time behind my computer and more in the field.

I confine my interventions to a few basic processes — exposure, contrast, cropping and a little sharpening where necessary. I always import my photos as Raw files (in my case, using Canon's proprietary software). Raw is like a digital negative that preserves an enormous amount of information about the image — much more than you will ever use. Guided by the histogram, I first improve the exposure. Then I select my preferred 'white balance' to make the tones warmer or cooler. This feature is a great advantage, as it saves you having to select the white balance manually for each shot.

Depending on the shape of the histogram, I then adjust contrast and the black and white sliders to get an even spread of tones. If the dark areas show too little detail, and especially if you've blown out the lightest tones, then the shadows and highlights sliders are invaluable tools.

At this point, I import the file into Photoshop Elements where I first crop the image, then attend to any areas that need lightening or darkening (dodging and burning, to use terms from the

far-off days of manual film developing). Then, after a final check of the histogram (in 'levels'), I save the image in two files, both JPEGs. The first is full size and the second is a smaller version designed for use on the web, in emails and so on. The dimensions of this smaller file — 1620 pixels on the horizontal side and 1080 on the vertical — are also standard maximum sizes for many competitions and exhibitions.

Finally, I apply a small amount of sharpening to this second image, as some softening may occur when it is reduced in size. Generally, I discard any image that is not absolutely sharp — you can always (well, mostly) go back and have another go!

Keeping track of stuff …

As you accumulate more images, you will need to devise a system that will enable you to search and retrieve them easily. Editing apps like Lightroom offer sophisticated image organizers, but by naming my images carefully, dividing them into large and small sizes and dropping them into different folders, I can soon find what I'm looking for. The large files remain in the original folders created by my photo-importing software (along with their associated Raw files), while the small files go into folders based on the subject's name. My file names typically take the form 'NZ dotterel, Awarua Bay141(l)' or 'Tomtit, Orokonui120(s)'. This method should work well if your output is not too large.

Acknowledgments

Looking back, this book has been a long time gestating, and I want to thank those who have helped bring it to birth. I cut my teeth as a photographer at the Dunedin Photographic Society, where over the years I have learned a good deal from the club's leading wildlife specialist, Craig McKenzie. Thank you, Craig. Latterly, I have taken a younger photographer under my wing, Neale McLanachan, who is the 'photo buddy' mentioned in the text. Neale keeps me up to the mark in all sorts of ways. As in all good relationships of this kind, the benefits are mutual.

At Exisle, my thanks go to proprietor Gareth St John Thomas, who encouraged me to write the book, the always efficient, astute and friendly Anouska Jones and Gareth's son Nathan Thomas, who helped choose the title. My copy-editor Karen Gee has enlivened the text with her light but sure touch and designer Mark Thacker has made the book look beautiful. Russell Drew, of Jonathan's Photo Warehouse in Dunedin, kindly read the section on camera options and made some useful suggestions. The staff at Orokonui Ecosanctuary, 20 minutes' drive from my home, have been helpful, courteous and always supportive of myself and other photographers wanting to explore the reserve. Orokonui is my 'local patch' and, as this book shows, my debt to it and its friendly guardians is extensive.

Finally, I owe a lot to the relaxed atmosphere and welcoming staff at the Dog with Two Tails in Dunedin, where I wrote a good deal of this book over a succession of large flat whites.

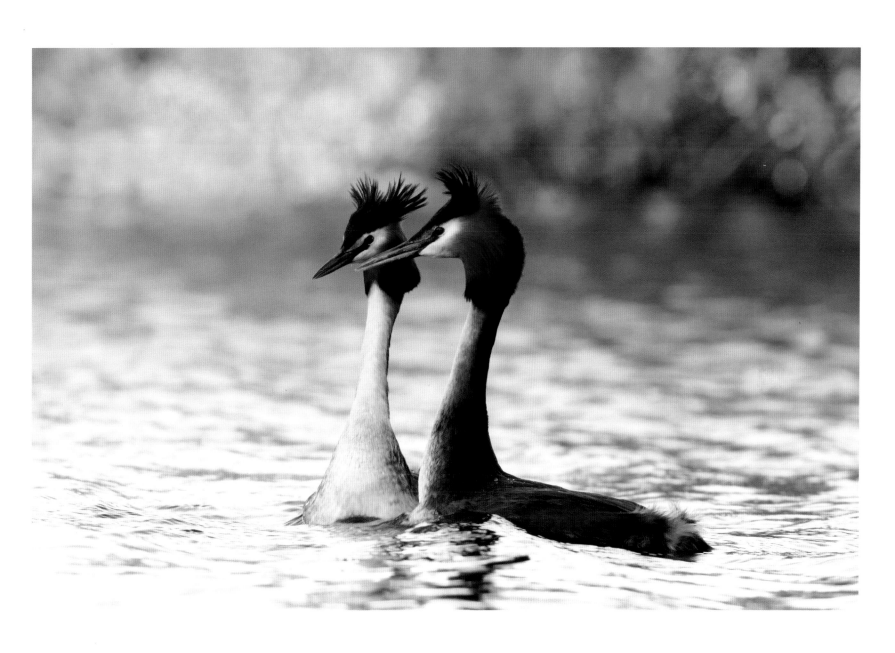

References

A Nature and Wellbeing Act: A Green Paper from the Wildllife Trusts and the RSPB: A briefing, http://ww2.rspb.org.uk/Images/natureandwellbeing-short_tcm9-384573.pdf

Australian Bureau of Statistics, 'Media release: How healthy is the typical Australian?', *National Health Survey: First Results, 2017–18*, 12 December 2018, https://www.abs.gov.au/ausstats/abs@.nsf/Lookup/by%20Subject/4364.0.55.001~2017-18~Media%20Release~How%20healthy%20is%20the%20typical%20Australian%3f%20(Media%20Release)~1

Australian Institute of Family Studies, 'Children's screen time', from *Growing Up in Australia: The Longitudinal Study of Australian Children, 2015 Report*, September 2106, https://aifs.gov.au/publications/childrens-screen-time

Barnes, Simon, 'Where the wild things are: Exploring the outdoors together as father and son', *The Guardian*, 22 August 2015, https://www.theguardian.com/lifeandstyle/2015/aug/22/exploring-outdoors-june-wild-nature-history-father-son

Bernabe, Richard, *Wildlife Photography: From first principles to professional results*, London, Ilex, 2018.

Birds New Zealand, 'Code of conduct for the photography of birds', https://www.birdsnz.org.nz/wp-content/uploads/2019/05/Code-of-Conduct-for-Photography-of-Birds-Guidelines.pdf

'Call of the wild', *Digital SLR Photography*, October 2017, p. 95, Roie Galitz interview.

Carrington, Damian, 'Three-quarters of UK children spend less time outdoors than prison inmates — survey', *The Guardian*, 25 March 2016, https://www.theguardian.com/environment/2016/mar/25/three-quarters-of-uk-children-spend-less-time-outdoors-than-prison-inmates-survey

Carwardine, Mark, 'The good, the bad & the ugly', *BBC Wildlife*, May 2010, pp. 58–63, https://www.markcarwardine.com/uploads/articles/bbc_wildlife/ethical_photography.pdf

Clayton, Susan et al., *Mental Health and our Changing Climate: Impacts, implications, and guidance*, Washington, DC, American Psychological Association and ecoAmerica, 2017, https://www.apa.org/news/press/releases/2017/03/mental-health-climate.pdf

Ducharme, Jamie, 'Only 23% of Americans get enough exercise, a new report says', *Time*, 28 June 2018, https://time.com/5324940/americans-exercise-physical-activity-guidelines

Earth Rangers, http://www.earthrangers.org/parents

'Environmental work in Brecon Beacons estate handed to young people', *BBC News*, 11 July 2019, https://www.bbc.com/news/av/uk-wales-48939663/environmental-work-in-brecon-beacons-estate-handed-to-young-people

Gill, Victoria, 'Bird populations in US and Canada down 3bn in 50 years', *BBC News*, 19 September 2019, https://www.bbc.com/news/science-environment-49744435

Hoddinott, Ross and Ben Hall, *The Wildlife Photography Workshop*, Lewes, UK, Ammonite Press, 2013.

Howard, Maureen, 'All at sea', *Otago Daily Times*, 16 September 2019, https://www.odt.co.nz/lifestyle/resilient/all-sea, on the plight of the yellow-eyed penguin.

Ippolito, Denise, '9 creative ways to drastically improve your wildlife photos', *Nature TTL*, https://www.naturettl.com/a-guide-to-fine-art-wildlife-photography

Jamieson, Philippa, 'Living the change', *OrganicNZ*, https://organicnz.org.nz/magazine-articles/living-the-change/, Robert Guyton interview.

Juniper, Tony, *What's Nature Ever Done for us? How money really does grow on trees*, London, Profile Books, 2013.

Lindo, David, *The Urban Birder*, London, Bloomsbury Natural History, 2015.

Louv, Richard, *Last Child in the Woods: Saving our children from nature-deficit disorder*, New York, Algonquin Books, 2005.

McCarthy, Michael, *The Moth Snowstorm: Nature and joy*, London, John Murray, 2015.

McCarthy, Michael, 'Wildlife photography might be stunning, but it's wildlife art that conveys deeper truths', *The Independent*, 13 October 2014, https://www.independent.co.uk/voices/comment/wildlife-photography-might-be-stunning-but-its-wildlife-art-that-conveys-deeper-truths-9792024.html

McGrath, Matt, 'Nature crisis: Humans "threaten 1m species with extinction"', *BBC News*, 6 May 2019, https://www.bbc.com/news/science-environment-48169783

Miyazaki, Yoshifumi, *Shinrin-yoku: The Japanese way of forest bathing for health and relaxation*, London, Aster, 2018.

Moss, Stephen, *Natural Childhood*, The National Trust, 2012, https://nt.global.ssl.fastly.net/documents/read-our-natural-childhood-report.pdf

Munro, Bruce, 'Less of a walk, more of a journey', *Otago Daily Times*, 8 July 2019, https://www.odt.co.nz/lifestyle/magazine/less-walk-more-journey

NHS Digital, *Health Survey for England 2017 [NS]*, https://digital.nhs.uk/data-and-information/publications/statistical/health-survey-for-england/2017

Orbell, Margaret, *Birds of Aotearoa: A natural and cultural history*, Auckland, Reed, 2003.

Reid, Liz, 'How to take better bird photographs', *Amateur Photographer*, 26 October 2018, https://www.amateurphotographer.co.uk/latest/articles/take-better-bird-photographs-123041, Johan Carlberg interview.

Ro, Christine. 'The harm from worrying about climate change', *BBC Future*, 11 October 2019, https://www.bbc.com/future/article/20191010-how-to-beat-anxiety-about-climate-change-and-eco-awareness, Caroline Hickman interview.

Rosenberg, Kenneth V. et al., 'Decline of the North American avifauna', *Science*, vol. 366, issue 6461 (4 October 2019), pp. 120–24.

Simmonds, Charlotte et al., 'Crisis in our national parks: How tourists are loving nature to death', *The Guardian*, 20 November 2018, https://www.theguardian.com/environment/2018/nov/20/national-parks-america-overcrowding-crisis-tourism-visitation-solutions)

State of Nature Report 2019, https://nbn.org.uk/wp-content/uploads/2019/09/State-of-Nature-2019-UK-full-report.pdf

Ulrich, Roger S., 'View through a window may influence recovery from surgery', *Science*, vol. 224, issue 4647 (27 April 1984), pp. 420–21.

Walsh, Jeremy J. et al., 'Associations between 24 hour movement behaviours and global cognition in US children: A cross-sectional observational study', *The Lancet Child & Adolescent Health*, vol. 2, issue 11 (2018), pp. 783–91.

Williams, Florence, 'This is your brain on nature,' *National Geographic*, January 2016, pp. 48–69.

World Wildlife Fund, *Living Planet Report – 2018: Aiming higher*, https://www.wwf.org.uk/sites/default/files/2018-10/wwfintl_livingplanet_full.pdf

Index

Page numbers in italics refer to illustrations